THE COURTAULD GALLERY *Masterpieces*

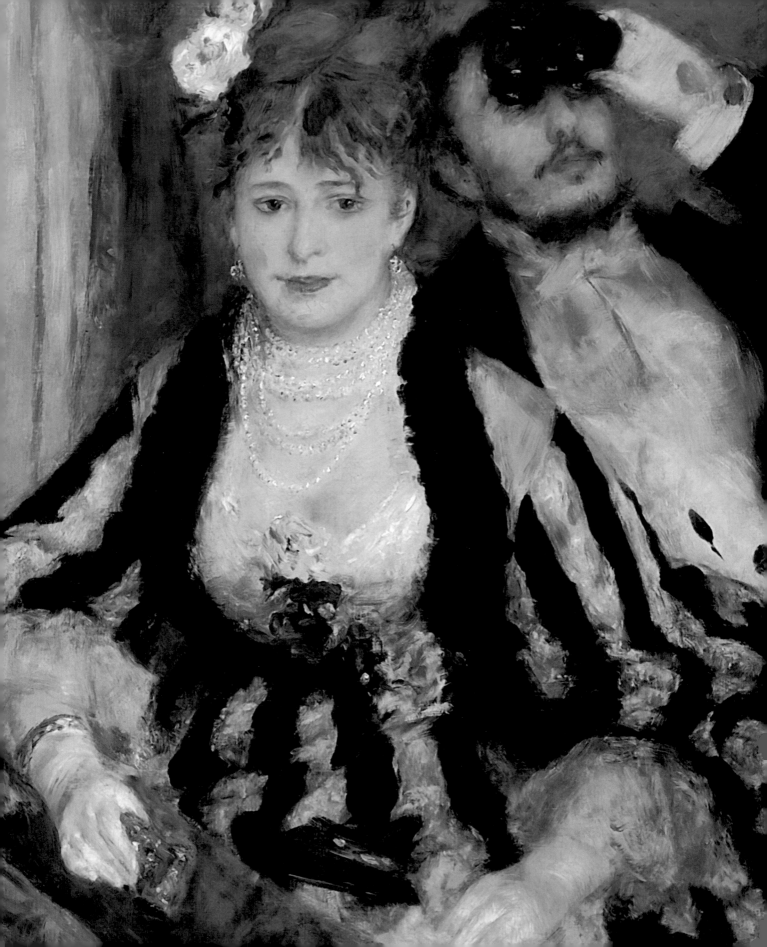

THE COURTAULD GALLERY

Masterpieces

SCALA

THE TEXTS WERE WRITTEN BY
THE FOLLOWING AUTHORS:

HELEN BRAHAM (HB)

STEPHANIE BUCK (SB)

CAROLINE CAMPBELL (CMC)

JOANNA CANNON (JC)

PETER DENT (PD)

ANTONY EASTMOND (AE)

ALEXANDRA GERSTEIN (AG)

PAUL HILLS (PH)

JOHN HOUSE (JH)

JOHN LOWDEN (JL)

SARAH MONKS (SM)

SUSIE NASH (SN)

STEPHANIE PORRAS (SP)

PATRICIA RUBIN (PLR)

JOANNA SELBORNE (JS)

ERNST VEGELIN VAN CLAERBERGEN (EV)

BARNABY WRIGHT (BW)

First published in 2007 by
Scala Publishers
Northburgh House
10 Northburgh Street
London EC1V 0AT
Telephone: +44 (0) 20 7490 9900
www.scalapublishers.com

ISBN-13: 978-1-85759-487-4

Courtauld Project Manager: Nigel Dickman
Project Editor: Linda Schofield
Copy Editor for the English edition: Matthew Taylor
Copy Editor for the French edition: Anne Sefrioui
Translator: Martine Groult
Designer: Nigel Soper
Printed and bound in Italy

10 9 8 7 6 5 4 3 2 1

British Library Cataloguing in Publication Data.
A catalogue record for this book is available from the British Library.

Frontispiece: Pierre-Auguste Renoir, *La Loge*, 1874 (detail), see pp 80–81
Front cover: Edouard Manet, *A Bar at the Folies-Bergère*, 1881–82 (detail),
see pp 70–71

Back cover: Central staircase of the Courtauld Gallery,
designed by Sir William Chambers (1723–96)

FOREWORD

THE COURTAULD INSTITUTE OF ART is a unique institution not just in Britain but also in the world. Founded 75 years ago as a result of the inspiration of three far-sighted individuals, textile magnate Samuel Courtauld, civil servant and politician Arthur, Lord Lee of Fareham, and lawyer Sir Robert Witt, the Courtauld has gone from strength to strength. Initially set up in Home House, the former home of Samuel Courtauld, the Courtauld Institute of Art was the beneficiary also of many of the great masterpieces that he had collected in the 1920s. These works were both an inspiration and a focus of study for faculty and students. It is perhaps not surprising that with this passionate purpose the Courtauld Institute has continued to attract collections of great significance since those early days.

In 2002, in order to be free to determine its own future, the Courtauld became a self-governing college of the University of London, the smallest of the distinguished group that makes up the University. There are some 400 students studying art history, conservation and museum curatorship at the Courtauld at any one time – at undergraduate, graduate diploma, MA and PhD level. With a faculty of over 30 it is the largest such institution in the UK, and one of the most significant centres of teaching and research in art history and conservation internationally. Our distinguished alumni head national museums and galleries, university art history faculties, conservation departments and commercial galleries and auction houses around the world.

But the key to our unique position is the Gallery and the world-class collection of art that we are privileged to have at our heart – a 'collection of collections' brought together as a key element in the original conception of what an Institute of this sort should be. Our founding fathers were enlightened in their views – demanding in their concern for the very best of scholarship, but fundamentally humane in their wish that the works of art and the scholarship required for their best understanding be readily accessible to the widest audience possible. Today we embrace the same ideals, and I am delighted that this handsome book will encourage further enjoyment of our Gallery and its collections.

DEBORAH SWALLOW
Märit Rausing Director
Courtauld Institute of Art

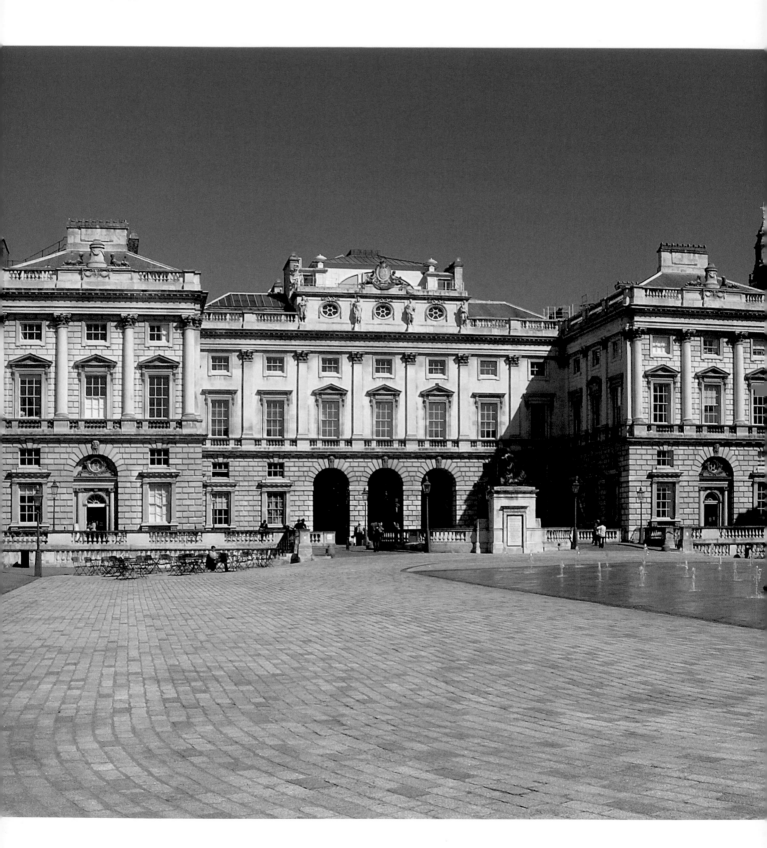

The Courtauld Gallery

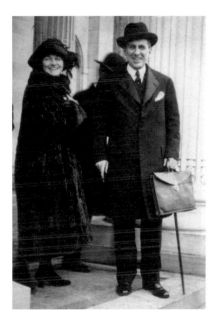

Lord Lee (1868–1947) and his wife Ruth in 1921 when Lee was First Lord of the Admiralty

The interior of Lord Lee's gallery in Avening

Opposite·
The north block of Somerset House, home to the Courtauld Institute of Art

THE COURTAULD GALLERY is one of the leading university art museums in the United Kingdom. Established in 1932 as an integral part of the Courtauld Institute of Art, its collection now numbers some 520 paintings, 7,000 drawings, 20,000 prints and over 550 works of decorative art and sculpture. Concentrating broadly, although with some notable exceptions, on the western tradition, and currently ranging in date from approximately 1300 to 1970, the collection includes single works of international fame as well as areas of sustained depth and quality. Despite its chronological coherence, it is not the result of a systematic programme of acquisitions but was formed through a series of outstanding gifts and bequests by some of the principal collectors of the late nineteenth and twentieth centuries. Each of these additions to the collection retains the unique character and imprint of its particular private origins while simultaneously contributing to the overall scope of the Gallery's holdings. It is a sequence of benefactions that remains essentially unbroken to the present day, and this guide may be read as a tribute to the philanthropy of a series of individuals united in their belief in the public role and benefit of the Courtauld Institute and its Gallery.

The founding of the Courtauld Institute of Art in 1932 was largely the result of the shared vision of two men: Viscount Lee of Fareham (1868–1947) and Samuel Courtauld (1876–1947). Arthur Lee retired from a political career in 1922. Having presented Chequers, his estate in Buckinghamshire, to the nation for use as a prime ministerial

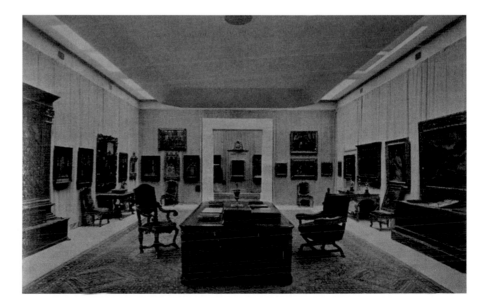

retreat, Lee was free to concentrate on the formation of his private art collection, an endeavour in which he was supported by his cherished American wife, Ruth. Viscount Lee was an intrepid and opportunistic collector. He relished the challenge of acquisitions and attributions, and he was emphatic in asserting the role of the private collector in the rapidly professionalising art world. He was particularly interested in works that had a representative character and therefore potentially an educational purpose. Craftsmanship was another abiding concern and saw Lee acquiring the great Morelli–Nerli marriage chests in the final months of his life. Among the Gallery's benefactors Lee was particularly exceptional in the degree of interest that he took in the practical questions relating to the display of works of art. He was first able to address these issues when he arranged his collection in White Lodge in Richmond Park, where he lived for 11 years. Lee subsequently constructed, to his own design, a much admired private gallery as an annexe to his last home, in Avening, Gloucestershire.

It was no doubt Lord Lee's direct experience of the art world, including a term as chairman of the National Gallery, that led him to identify the need in Britain for a specialist institute dedicated to the history of art. He was aware of the opportunities that existed for students in Austria and Germany but drew his principal inspiration from the Fogg Museum at Harvard University, where the teaching of the history of art was undertaken with immediate reference to the works themselves. It was always Lee's intention that his private collection be left for such a purpose to the institute that he would help to establish.

Lee's vision of a centre for training a new generation of academic art historians, museum curators and professional administrators found a perfect echo in Samuel Courtauld. Although he was an inherently modest and private man, Courtauld's contribution to the visual arts in Britain was perhaps unequalled in the twentieth century. In 1921 he became chairman of Courtaulds Ltd, the multinational textiles and chemicals company, which at the time derived much of its profits from the manufacture of rayon or viscose. Courtauld's early interest in Old Master painting was decisively redirected in 1917, when he saw the Hugh Lane collection of Impressionist art temporarily displayed at the National Gallery in London. Although the innovations of the Impressionists and Post-Impressionists were still viewed with a degree of scepticism in some quarters, to Courtauld they represented a powerful and necessary renewal of western art as a living and responsive force. Acting on this conviction, in 1923 he established a fund for the acquisition of modern French paintings for the nation. With a string of remarkable purchases that included Seurat's monumental *Bathers at Asnières* and Van Gogh's iconic *Sunflowers*, the Courtauld Fund shaped the national collection in this area. In addition to this unprecedented intervention in public taste, between 1922 and 1929 Courtauld assembled a private collection of staggering quality. Acquisitions such as Cézanne's *Still Life with Plaster Cupid* in 1923, Renoir's *La Loge* in 1925 and Manet's *A Bar at the Folies-Bergère* the following year rapidly established Courtauld as one of the major figures on the international art market, matched in means and commitment only by a small band of principally American collectors. Acting some 50 years after the first Impressionist exhibition in 1874, it is difficult to characterise Samuel Courtauld as a pioneering collector, even in the context of English taste. Nevertheless, his absolute commitment to the 'modern movement', exemplified perhaps above all by his profound and intuitive response to the art of Cézanne, was, and remains, unequalled in this country.

Samuel Courtauld (1876–1947)

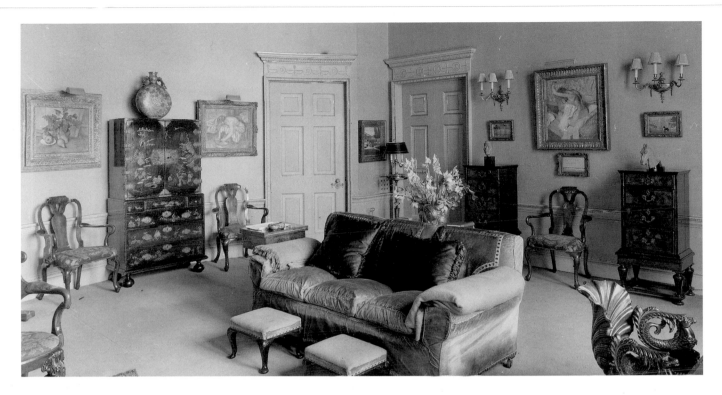

The drawing room at Home House, with works from Samuel Courtauld's collection

The paintings that Courtauld acquired for his private collection in this brief but intense campaign came to hang at Home House, the splendid home in Portman Square, built by Robert Adam in 1774, that he shared with his wife, Elizabeth, and their daughter Sydney. Although Courtauld was self-evidently knowledgeable, his collection was by no means assembled on scholarly or museological principles. For Samuel Courtauld it was the subjective response that mattered, the transcendent qualities of art and its appeal to the imagination and the spirit. His deeply held belief in art's regenerative power and its value to the individual and society complemented his progressive ideas on employment practices. It was this vision of the public benefit of art, and therefore the responsibility of those who administer and study it, that Courtauld brought, along with much else, to the founding of the Courtauld Institute. The Institute, it was agreed, could not be for a small band of specialists but must always find the means to share its expertise with a broad public. The Gallery would play a central role in this.

Samuel Courtauld agreed to provide the bulk of the funding for the new history of art institute. With the help of further donations from Sir Robert Witt, John Graves, Joseph Duveen, Martin Conway and others the Courtauld Institute of Art was duly established as part of the University of London. Soon after the death of his wife, Elizabeth, in 1931, Courtauld presented the Institute with the home that they had shared, establishing the Home House Society in her memory and endowing it with his collection. The doors of the Courtauld Institute opened at Home House in October 1932, offering its students a wide range of courses. At Lee's insistence the new Courtauld Institute of Art also rapidly established a department for the conservation and technical study of works of art, which remains one of its great assets to this day.

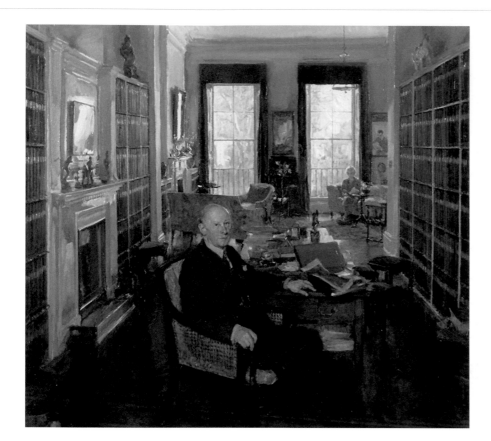

Oswald Birley (1880–1952)
Sir Robert Witt in his Library, 1931

Thomas Gambier Parry (1816–88)

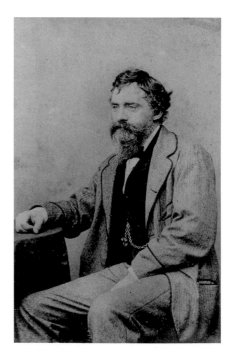

In 1958 the collection moved from Home House to newly built galleries in Woburn Square, Bloomsbury. The Gallery had already benefited from a number of additional gifts and bequests. Sir Robert Witt (1872–1952) had been one of the original supporters of the initiative to establish the Courtauld Institute and on his death bequeathed to it his outstanding collection of prints and Old Master drawings. Witt collected drawings in quantity at a time when the lesser-known masters were still readily available and attributions often uncertain. His bequest of approximately 3,800 drawings forms the core of the Courtauld's extensive collection of works on paper and it endowed the Gallery with the important ability to show and study the best of the graphic arts alongside its famous paintings. Roger Fry (1866–1934), the influential art historian, critic and painter, was another early supporter of the Institute. Fry left the Gallery an eclectic private collection that speaks eloquently of his life as an artist and intellectual. The bequest includes paintings by his bohemian friends of the Bloomsbury Group and avant-garde designs by the Omega Workshops, as well as examples of non-western art, which played such an important part in the development of his aesthetic theories.

At the opening celebrations for the new gallery in Bloomsbury the promised gift of another renowned collection was announced: that formed by the Victorian collector Thomas Gambier Parry (1816–88), which was eventually bequeathed by his grandson Mark Gambier-Parry in 1966. At the heart of Thomas Gambier Parry's collection is a major group of early Italian gold-ground paintings by artists such as Lorenzo Monaco, Bernardo Daddi and Fra Angelico. Gambier Parry was one of a small number of

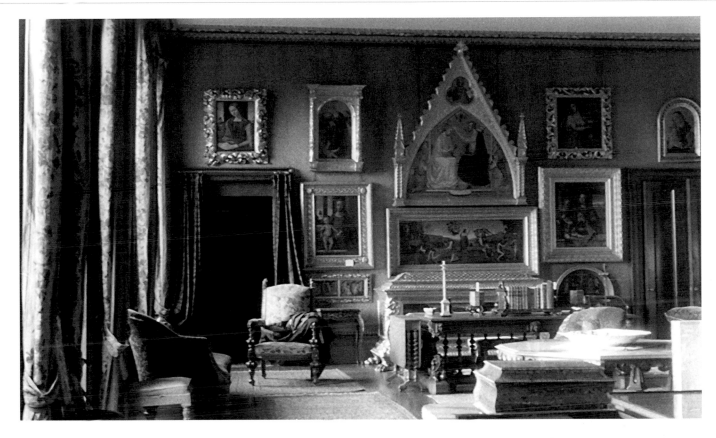

The Interior of Highnam
Court, with works from
Thomas Gambier Parry's
collection

collectors in Britain who recognised the historical importance of early Italian painting
and for whom the aesthetic qualities of fourteenth- and fifteenth-century art resonated
with progressive ideas on spiritual reform and renewal. The collection was installed
at Highnam Court in Gloucestershire, where Gambier Parry also personally decorated
the estate church with a series of remarkably successful and technically innovative
frescoes. In addition to early Renaissance paintings, Gambier Parry acquired Gothic
ivories, Limoges enamels, sculpture, maiolica, glassware and a small but highly
important group of Islamic metalwork. This material now forms the core of the
Gallery's collection of decorative art. The Gambier-Parry Bequest presents an admirably
integrated view of the field of artistic production where the hierarchy of fine art and
craft, of the aesthetic and the functional object, is open and fluid.

The collection of works on paper established by Sir Robert Witt in 1952 also enjoyed
further growth. In 1967 the Gallery was presented with the superb collection of English
watercolours formed by William Wycliffe Spooner (1882–1967) and his wife, Mercie.
This emerging area of special strength was further enhanced in 1974 with the bequest
of the fine group of J.M.W. Turner watercolours assembled by Samuel Courtauld's
brother Sir Stephen Courtauld (1883–1974). Four years later the Princes Gate Collection
arrived and at stroke elevated the Gallery to an entirely new level of public importance.

The Princes Gate Bequest was one of the most significant gifts to a British
museum in the twentieth century. Assembled by Count Antoine Seilern (1901–78) and
named after his London address, the collection includes some 130 paintings and 400

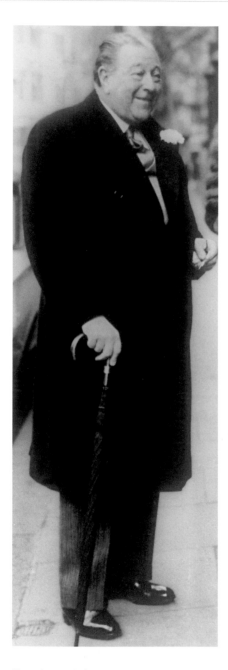

Count Antoine Seilern (1901–78)

drawings. It is remarkable not so much for its scale as for its sustained quality. For several generations of Courtauld students a trip to 56 Princes Gate was an exceptional visual and intellectual treat. After passing through an entrance hall decorated with Oskar Kokoschka's vast *Prometheus Triptych*, one might be shown drawings by Dürer, Michelangelo or Rembrandt, study one of the greatest private collections of work by Rubens, or enjoy such masterpieces as Campin's *Entombment Triptych* and Bernardo Daddi's exquisite portable tabernacle of 1338.

Seilern, who moved to London in 1939 after completing a PhD on Rubens at the University of Vienna, sympathetically embodied the ethos and values of the scholar–collector. He conducted voluminous correspondence with academics, curators and research students, assembled an extensive reference library of books and comparative photographs, travelled widely to study works in museums, exhibitions and churches, and published a series of methodically researched catalogues of his collection. In Seilern there co-existed an appreciation of the beauty of a finished work with an understanding of the complexity of its creation. Seilern's particular interest in artists' working processes is evident from the large number of oil sketches in the Princes Gate Collection, including important examples by Tiepolo and Rubens. Similarly, Seilern sought systematically to acquire groups of closely related works, such as Rubens's painted designs for the ceiling of the Jesuit church in Antwerp. As paintings became more expensive, he shifted his attention to drawings, eventually assembling a collection of international renown that, in the outstanding quality of the individual works, perfectly complements the depth and range of Sir Robert Witt's founding bequest to the Gallery's drawings department.

The success of the Gallery and its special character as a 'collection of collections' has continued to attract gifts in more recent decades. The prescient interest of Dr Alastair Hunter (1909–83) in modern British art brought a previously unrepresented area into the collection. In 1984 the unforgettable Lillian Browse (1906–2005) presented the Courtauld with the private collection of twentieth-century paintings, drawings and sculptures that she had formed alongside her successful career as a dealer. As with the Gallery's other constituent collections, Lillian Browse's gift retains a strong personal character. It includes works by Degas and Rodin that express her passion for ballet, as well as a group of paintings by Walter Sickert, on whom she published two important early studies.

By the 1980s the Gallery had fully outgrown its home in Bloomsbury. When the Courtauld Institute's lease on Home House expired, new premises were sought that would once again reunite the collections in a single building with the Institute's teaching and research activities. A solution was found in Somerset House, designed by Sir William Chambers (1723–96) and regarded as one of the most important Georgian buildings in Britain. The collection moved to its new home in 1989. Arranged over three floors of the north block of Somerset House, the Gallery now occupies the premises that Chambers designed for the principal learned societies of the eighteenth century: the Society of Antiquaries, the Royal Society and the Royal Academy. The societies' council chambers and formal meeting rooms, with their rich decorative schemes, can be enjoyed on the first floor, whereas the architectural climax of the building comes at the top of the final flight of steep stairs. Here Chambers built the Great Room, used by Royal Academy for the annual exhibitions that constituted one of the great spectacles of Georgian London.

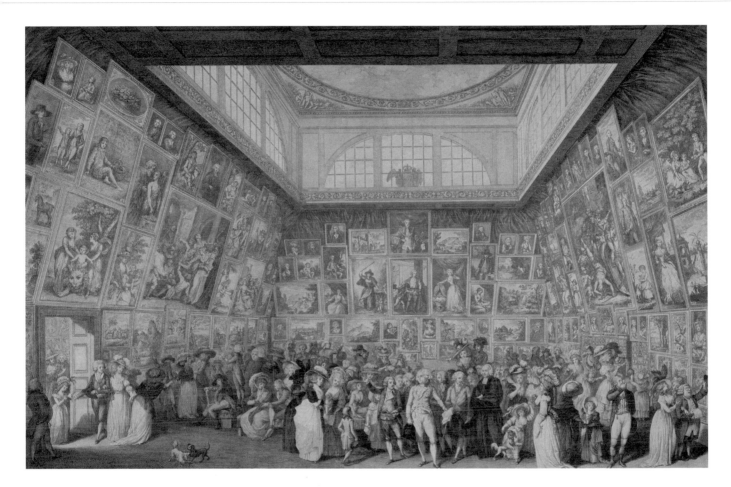

P.A. Martini after J.H.Ramberg
*The Exhibition at the Royal
Academy*, 1787
Gift of David, Benjamin
and Mia Solkin in memory
of Sally Kolker

Consolidated at Somerset House and, since 2002, constituted as a fully self-governing college of the University of London, the Courtauld has been able to resume with renewed vitality the vision of a world-class specialist institute dedicated to the history of art, with the Gallery contributing fully to the public role enshrined by Lord Lee and Samuel Courtauld. The mission articulated by Lee and Courtauld in 1932, and endorsed by each great and small act of philanthropy in the years since then, has continued to inspire support. In 2007 the collection of works on paper was further enhanced by the bequest of 50 important British watercolours assembled by Dorothy Scharf. No less significant are the long-term loans which have brought outstanding Fauve and German Expressionist works into the displays for the first time, demonstrating the creative continuities between Post-Impressionism and the revolutionary artistic developments of the early twentieth century. History provides grounds for quiet confidence that the ambition to develop the collections permanently along such lines may once again find a sympathetic response among those who share Samuel Courtauld's public-spirited view of the essential importance of art.

ERNST VEGELIN VAN CLAERBERGEN
Head of the Courtauld Galleries

WALLET
Western Iran (Tabriz),
early 14th century

Brass, inlaid with gold and silver
15.2 x 22 x 13.5 cm
Gambier-Parry Bequest, 1966

This ornamental wallet is the finest piece of Islamic metalwork in the Courtauld collection. It belongs to a small but distinguished group of Islamic objects that were acquired by the Victorian collector Thomas Gambier Parry (1816–88). Its most important feature is the banqueting scene on the lid, showing a ruling couple seated on a long, low throne. The sovereign is accompanied by a falconer and by courtiers, who offer wine in sumptuous vessels. His consort is similarly attended by servants and musicians, and, although her face is now missing, it can be seen reflected in the mirror held by the man immediately next to her. Images of joint enthronements are most common in art of the Ilkhanid dynasty, which ruled greater Iran from 1258 to 1335, and this suggests the most likely context for the object. The wavy diaper pattern and the images on the sides of the wallet are indebted to long-established traditions that can be traced back to Syria and Iraq in the early thirteenth century.

The sides of the wallet are decorated with medallions, each of which contains an image of a seated musician or servant, with two larger medallions of mounted hunters on the front and back. Like the banqueting scene, these evoke the courtly world of hunting, feasting and enjoyment of the arts that was promoted by the Islamic aristocracy throughout the Middle East in this period. Although the function of this container is unclear, its value to its owner is spelled out in the inscription on the lid, which presents a never-ending circle of benedictions: 'glory, prosperity, favour, excellence, fulfilment of hopes, righteousness, respect...'. AE

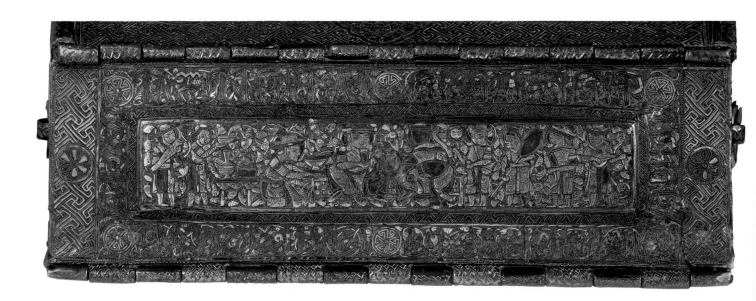

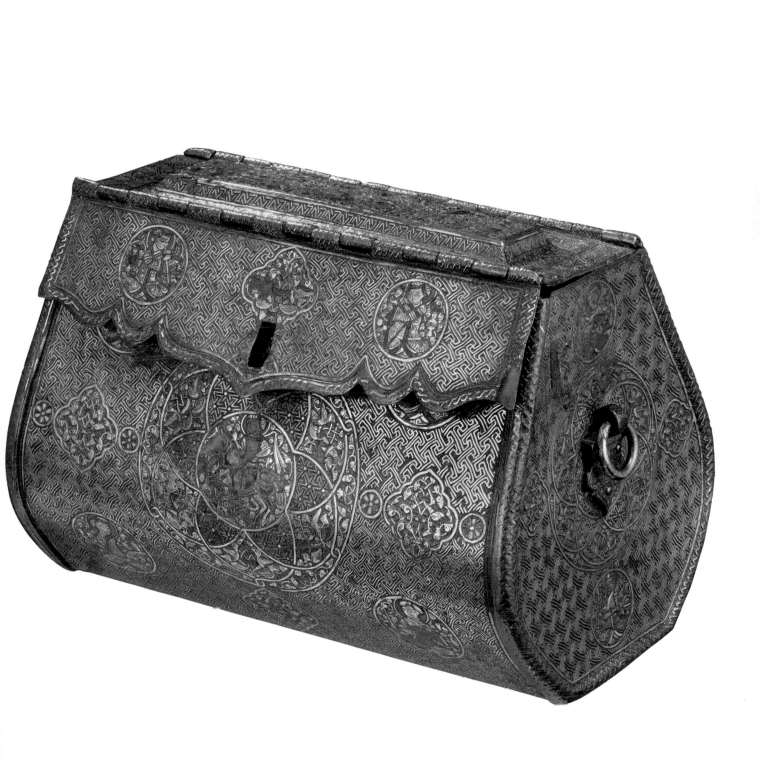

BERNARDO DADDI (recorded from 1327, died 1348)
Triptych: *The Virgin and Child Enthroned with Saints and Angels* (centre); *The Almighty* (above); *The Nativity, The Crucifixion, The Four Evangelists, The Annunciation* (inside of wings); *The Adoration of the Magi, Two Bishop Saints* (outside of wings), 1338

Tempera and gold leaf on panel
87.5 x 42.5 cm (centre), 62.7 x 18.7 cm (wings)
Samuel Courtauld Trust: Princes Gate Bequest, 1978

This triptych is an exquisite example of the portable tabernacles produced for private patrons in fourteenth-century Italy. It is attributed to the Florentine artist Bernardo Daddi, and the date *ANNO.DNI.[M].CCC.XXXVIII* (1338) is inscribed on its plinth. Daddi, who felt the influence of both Giotto and of his Sienese contemporaries, ran a well-organised and prolific workshop. This triptych ranks amongst the finest of his small-scale works, for the refinement of its execution, the quality of its narrative invention and its excellent condition. The images form a compendium of Christian belief, watched over by the Almighty in the apex of the tabernacle: the Incarnation of Christ, heralded by the Annunciation, and confirmed at the Nativity, culminates in Christ's redemptive sacrifice at the Crucifixion.

Doctrine is made vivid to the viewer through narrative detail, helping to stimulate prayer and meditation. Reciprocal glances and gestures recur throughout the triptych. The Nativity, for instance, is enlivened by the tender communication between mother and child; Gabriel's salutation and the Virgin's hesitant response link the two parts of the Annunciation crowning the inner faces of the shutters. When the tabernacle is closed, paintings on the reverse of the shutters unite to form the scene of the Adoration of the Magi. On the left wing two of the Magi gaze and gesture towards the star beyond the central framing moulding. Turning this interruption to advantage, the artist continues the rocky landscape beyond the frame, creating the illusion of a single scene, witnessed through a pair of arched windows. JC

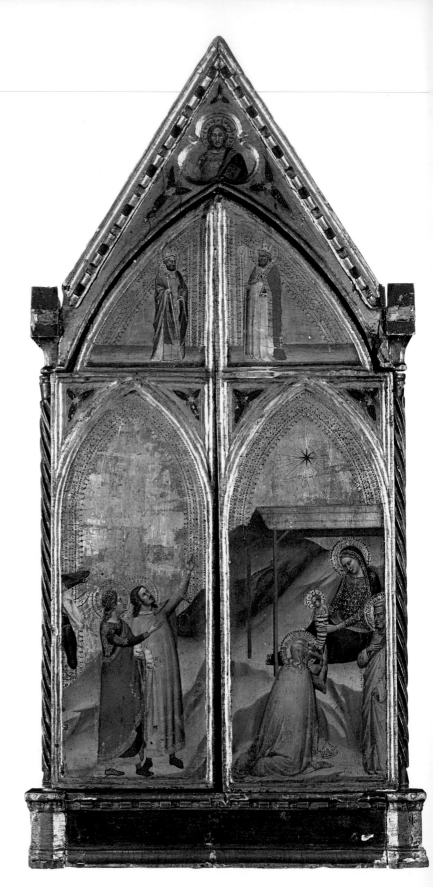

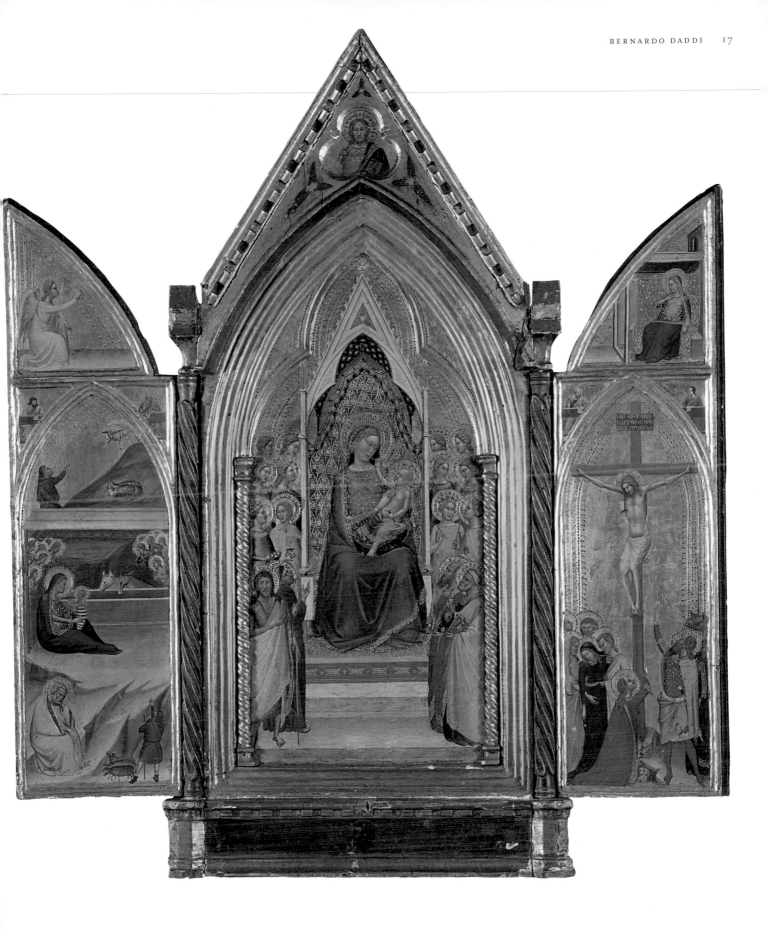

FRANCE (PARIS), *c.1360–80*
*Diptych with scenes from
the life of Christ*

Elephant ivory, two panels
19.7 x 21.5 cm
Gambier-Parry Bequest, 1966

This beautifully carved and superb Gothic ivory is an example of what has been termed a 'Passion diptych'. Composed in three registers, and set in a stage-like space beneath trefoil-headed arches, the narrative of the ivory reads from left to right and anagogically (upwards, towards Heaven). Its scenes would all have been familiar to a medieval viewer: the Annunciation; Christ's Nativity, with the angels appearing to the shepherds in the background; the Adoration of the Magi, including the wonderfully vivid detail of the Magi's servant controlling their horses; the Betrayal, with Christ healing the ear of Malchus – it had been cut off by St Peter, who sheathes his sword at the left. Judas appears a second time at the right, hanging from a tree with his guts

spilling out. Next is the Crucifixion and Christ rising from the tomb; the Ascension, with the feet of the disappearing Christ observed by the standing apostles and Virgin; and finally Pentecost, with the dove of the Holy Spirit descending towards the seated apostles and Virgin. The depth of the ivory has been used with exceptional skill so that many of the figures appear to be free-standing. Diptychs such as this one may have stood on altars, perhaps in private chapels, and could have been set up to encourage meditation or to accompany prayer in some more domestic setting. The highly detailed carving was not merely a demonstration of artistic skill: it provided interest to capture and reward the attention of the devotee. JL

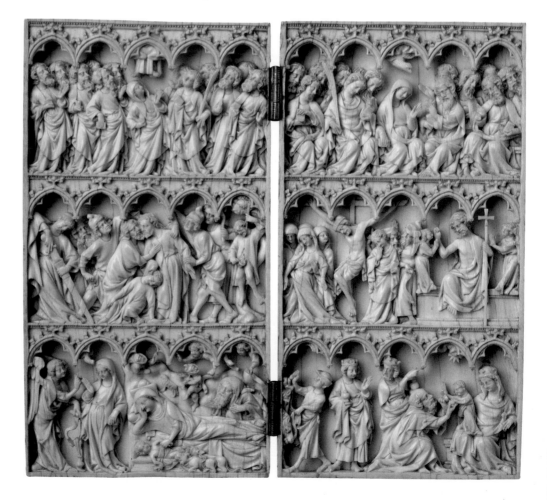

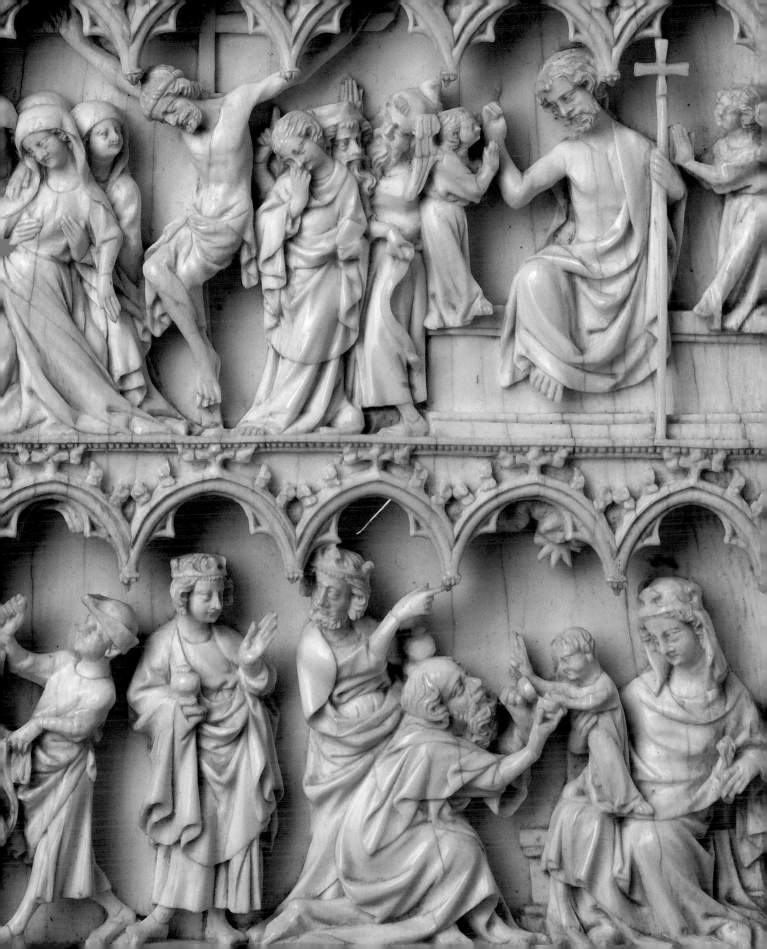

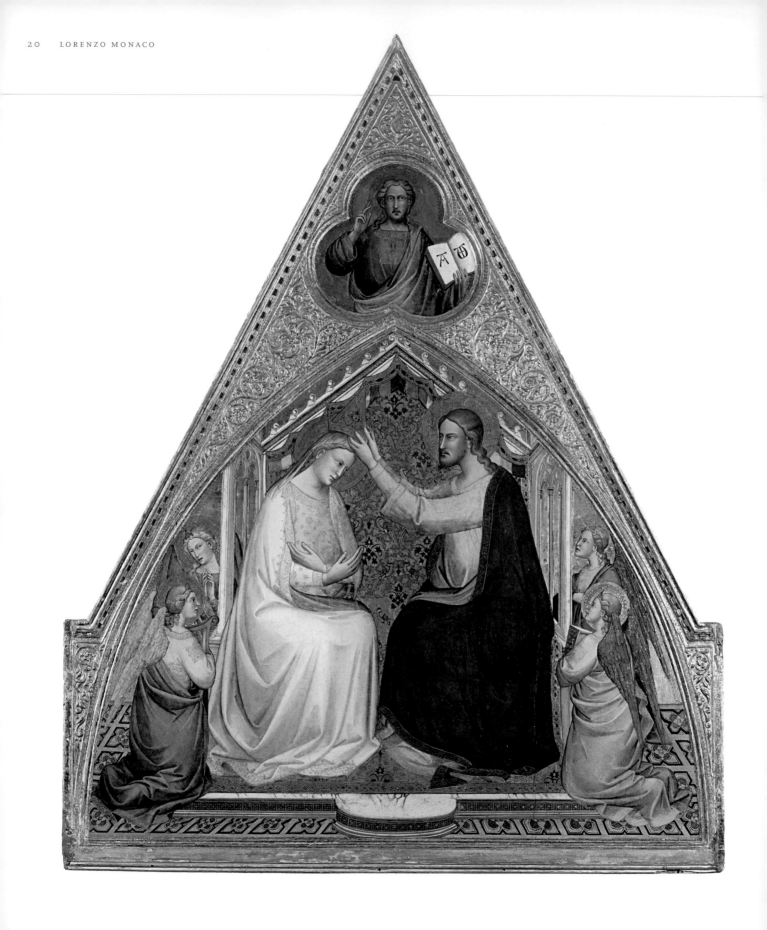

LORENZO MONACO
(*c*.1370– *c*.1425)
The Coronation of the Virgin,
c.1388–90

Tempera on panel
208 x 197 cm
Gambier-Parry Bequest, 1966

Around 1400 Lorenzo Monaco was Florence's leading painter. Born Piero di Giovanni (perhaps in Siena), he probably trained with the Florentine painter Agnolo Gaddi. Shortly after leaving Gaddi's studio he was ordained as a Camaldolese monk (a reformed branch of the Benedictines). He entered the convent of Santa Maria degli Angeli and assumed the name Lorenzo, by which he is known today.

This is one of Lorenzo's earliest independent works, probably executed just after he had left Gaddi's studio. It depicts Jesus's crowning of his mother, Mary, as Queen of Heaven, flanked by praying and music-making angels. Mary's robes have changed radically in colour: once violet, they now appear white because the red lake pigment they contain has faded from the cumulative effect of light. The richly gilded Oriental cloth of honour on which Christ and Mary sit has retained its bright blue and orange tones. This same fabric, patterned with birds, also appears in Nardo di Cione's *Three Saints* (National Gallery, London).

The *Coronation* is the pinnacle of an altarpiece painted for the female Augustinian convent of Santa Caterina al Monte e San Caio in Florence, probably for the convent church's high altar. Other fragments of this have been identified: *St Catherine* and *St Caius*, and three predella panels depicting the Last Supper and the martyrdoms of Sts Catherine and Caius. However, the central panel is missing. Recently, it has been suggested that no such painting was made, and that the *Coronation* crowned an empty space that connected the nuns' choir with the upper part of the church. CMC

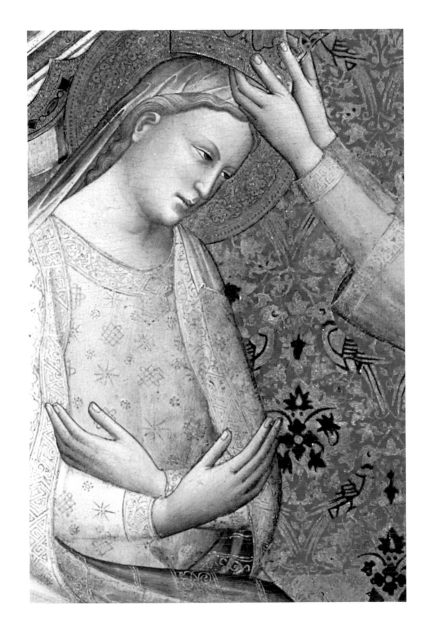

ATTRIBUTED TO ROBERT CAMPIN?
(active 1400–1450)
The Seilern Triptych:
The Entombment, c.1425

Oil and gold on panel
65.2 x 53.6 cm (central panel);
64.9 x 26.8 cm (each wing)
Samuel Courtauld Trust:
Princes Gate Bequest, 1978

The Seilern Triptych was painted by a highly talented artist who has been identified as the Tournai painter Robert Campin. However, no documentation survives concerning this work, and all we can deduce from it must be gleaned from the object itself. The triptych shows the narrative of Christ's Passion. On the left are depicted the remains of the Crucifixion, with an empty Cross and the two thieves; in the centre is the Entombment; on the right, the Resurrection. The panels are linked by a continuous landscape and the raised gold background. When open, the triptych was designed to be seen with the wings at a slight angle, in which position Christ's gaze and gesture is directed to the kneeling Magdalen, the first witness of his Resurrection.

In the left wing the unknown donor kneels with a blank scroll indicating his prayer (technical examination shows there was never any writing here). The unusual, and invented, purple flower placed prominently against the tomb in the main panel reappears on either side of his kneeling form and may be his motto.

Every aspect of this painting has been considered carefully. The gold background is decorated with plants holding symbolic meanings: redcurrants in the left wing, vines (referring to Mass and the Eucharist) in the centre, and the gourd, signifying the Resurrection, at the right. The work is rich in descriptive details, some of which can only be seen with magnification: for example, the figures in the central scene have red-rimmed eyes. The painter of this outstanding work was a master at manipulating paint and a perfectionist at creating textures, material and figures. SN

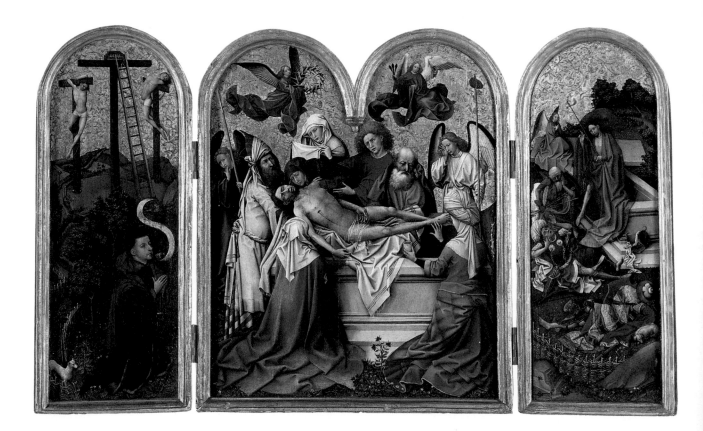

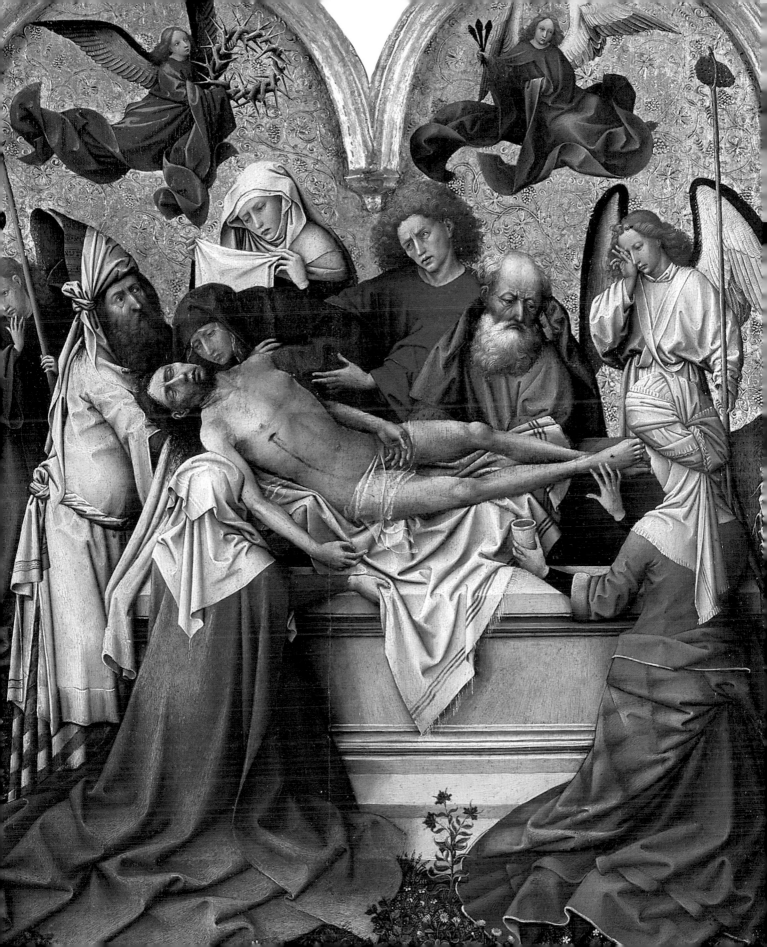

**FRA ANGELICO DA FIESOLE
(GUIDO DI PIERO)** (*c.*1395/1400–55)
Predella: *Catherine of Siena,*
St Cecilia (top panel); *St Mary*
Magdalen, The Dead Christ,
St John the Evangelist (central
panel); *St Catherine of Alexandria,*
St Agnes (bottom panel), after 1421
and before 1429

Tempera on panel
20.3 x 49.4 cm (top panel);
20.3 x 54.5 cm (centre);
20.3 x 50.7 cm (bottom panel)
Gambier-Parry Bequest, 1966

Fra Angelico is the name commonly given to the Domincian monk, painter and manuscript illuminator Guido di Piero, who passed much of his life in his Order's convent of San Domenico, Fiesole. These three small panels, which probably date from the early 1420s, formed the predella or base of an altarpiece painted for the convent of San Pietro Martire in Florence. The main section of this polyptych is now in the Museo di San Marco, Florence.

Predella panels physically supported the principal parts of an altarpiece. They were generally decorated with small-scale scenes or figures, which provided a commentary on the main images above. The depiction of Christ as the Man of Sorrows, flanked by the lance and sponge, instruments of his torture on the Cross, and accompanied by the mourning Mary Magdalen and John the Evangelist, originally sat directly below the main image of the Virgin and Child. This served to remind the viewer of the future sufferings of the infant Christ.

Female saints dominate these predella panels because San Pietro Martire housed Dominican nuns. A prominent position is given to Catherine of Siena. This Dominican nun was only canonised in 1461, yet here she is shown with a halo as if already a saint. She is accompanied by Cecilia, patron saint of musicians, while the final panel represents St Catherine of Alexandria (shown with the wheel on which her persecutors tried to murder her) and Agnes, who bears the Lamb of God (Agnus Dei). CMC

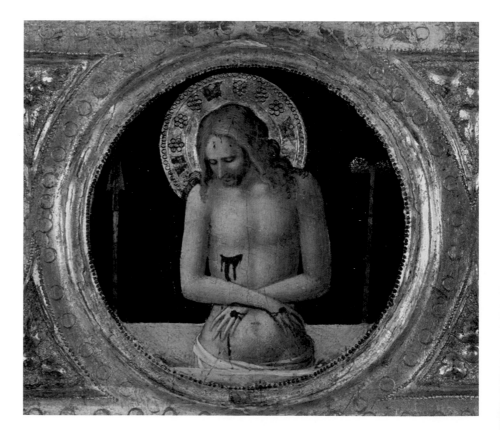

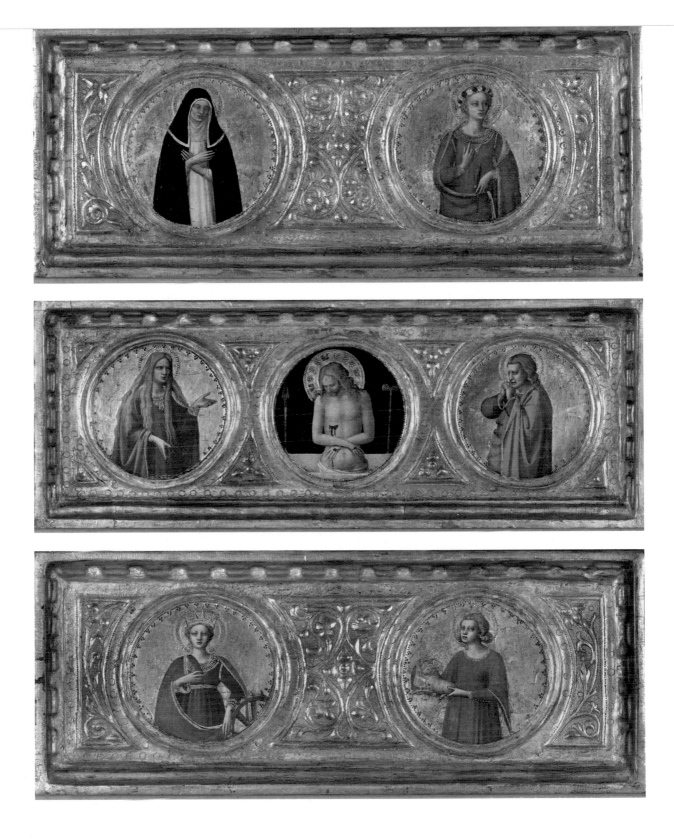

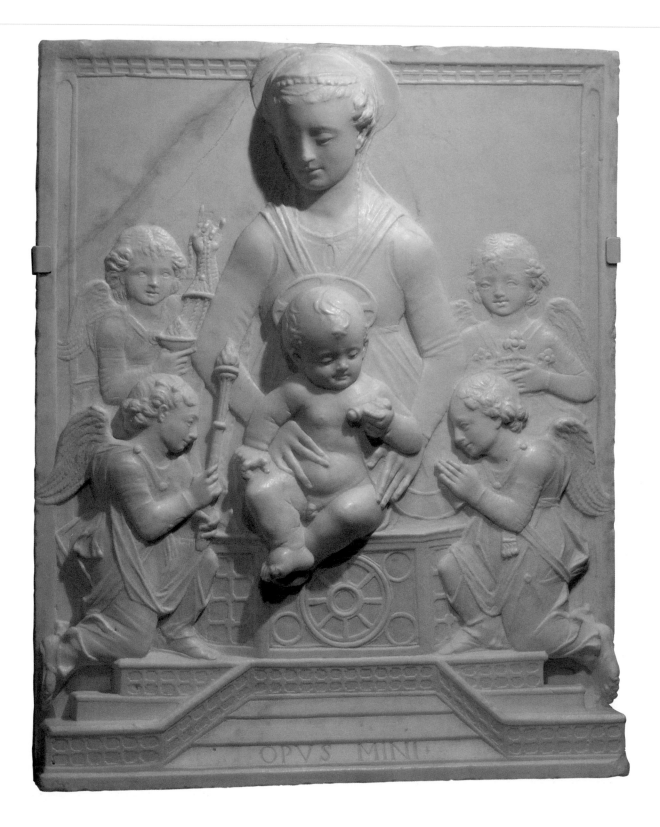

MINO DA FIESOLE (1429–84)
Virgin and Child with Angels,
*c.*1470?

Marble
45 x 36.2 x 7 cm
Gambier-Parry Bequest, 1966

In the centre of the panel the Virgin gently
steadies the naked Christ Child, who is
perched on a low parapet in front of her.
Her head is inclined to her right, whereas
Christ looks down to his left, apparently
concentrating his attention on the unfurled
scroll in his hand. The Virgin wears a
gamurra, the high-waisted gown common in
the period. Flanking the Mother and Child are
pairs of angels, three of whom carry objects –
a torch, a censer and a crown – while the
fourth raises his hands in prayer. Below, steps
run down to the left and right, to either side of
a shallower area that opens out towards the
viewer, inscribed in the centre with the words
OPVS MINI, the sculptor's trademark
signature. Mino enjoyed an extremely
successful career, running large workshops in
both Florence and Rome.

 The prominence of the architecture and
the size of the inscription may indicate that
the relief originally formed part of a larger
structure. The parapet, or altar, seems to be
polygonal in shape, perhaps evoking a
baptismal font. The existence at one time of a
stucco copy (now lost) demonstrates that the
design must have enjoyed some popularity as
an independent relief.

 The kneeling angels closely resemble
similar figures on a tabernacle by Mino for the
cathedral at Volterra (*c.*1467–71), which may
argue for the involvement here of assistants
using common designs. Nevertheless, the
quality of the shallow carving in the Virgin
and Child strongly suggests the intervention
of the master himself. PD

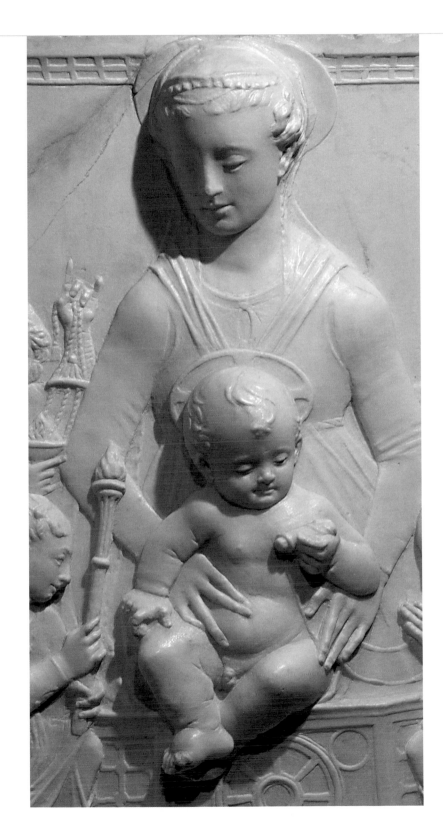

ZANOBI DI DOMENICO
(active 1470s),
JACOPO DEL SELLAIO
(c.1441–93) and
BIAGIO D'ANTONIO
(1446–1516)
The Morelli–Nerli chests,
1472

Tempera on poplar, with gilding
205.5 x 193 cm [each chest, overall],
45 x 162.5 cm [each *spalliera*]
Lee Bequest, 1947

In fifteenth-century Italy gilded and painted chests or *forzieri* (today generally called *cassoni*) were associated with marriage. Generally made in pairs and originally intended to carry the bride's dowry to her new home, they were placed in the chamber (*camera*) of the bridegroom, who commissioned them. Such chests could be the most valuable items in this multi-purpose space. This is the only pair of *cassoni* that has survived with their

accompanying *spalliere* (backboards) and which can be connected with their original documentation. In September 1472 the Florentine patrician Lorenzo Morelli paid Zanobi di Domenico 21 florins for a pair of chests. Later that year Jacopo del Sellaio and Biagio d'Antonio decorated them with painted histories and fine gold. Lorenzo purchased these *cassoni* to mark his marriage to Vaggia Nerli, and they prominently bear the arms of each family.

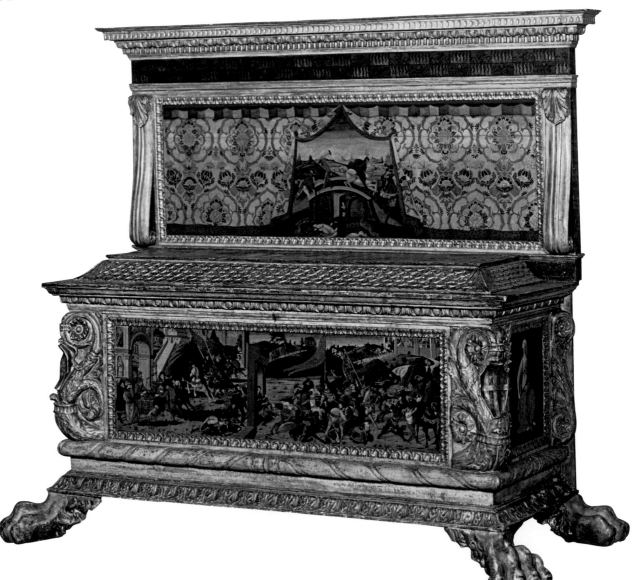

Presumably Lorenzo Morelli chose the painted stories adorning both chests. Drawn from Livy's history of ancient Rome, they were selected for their capacity to entertain and instruct the young couple, their household and family. The chest with the Morelli arms depicts Camillus' expulsion of the Gauls from Rome, flanked by the virtues of Fortitude and Justice, while its *spalliera* shows Horatius Cocles's defence of Rome. The Nerli *spalliera* portrays Mucius Scaevola's patriotic devotion, and the chest the punishment of the treacherous Schoolmaster of Falerii, who offered his pupils as hostages to the Romans. This exemplary lesson was probably aimed at Vaggia Nerli, who was encouraged to care for her husband's children with dedication, in contrast to the Schoolmaster. CMC

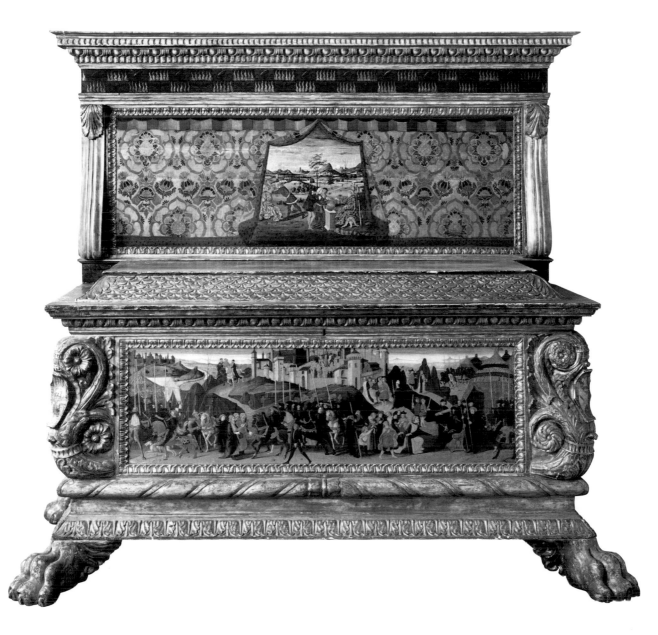

BOTTICELLI (ALESSANDRO FILIPEPI)
(*c.*1444–1510)
*The Trinity with St Mary Magdalen
and St John the Baptist, the Archangel
Raphael and Tobias*, 1491–94

Tempera and oil (?) on panel
214.9 x 191.2 cm
Lee Bequest, 1947

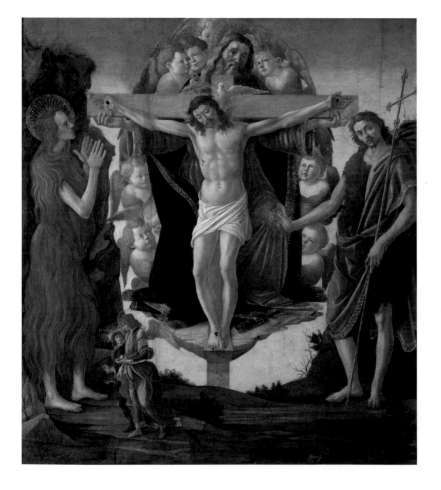

Identified as coming from the high altar of the
Florentine convent of repentant prostitutes –
Sant' Elisabetta delle Convertite – this imposing
work shows the Trinity as a vision of startling
clarity. Mary Magdalen, patroness of the convent
and inspiration to its inhabitants, turns towards
the Cross, gazing with loving wonder at the
crucified Christ. The story of her conversion
from sinner to saint is told in four small panels
once fixed below this painting, and now in the
Philadelphia Museum of Art. John the Baptist,
patron of the city of Florence and forerunner of
Christ, turns outward. The Magdalen is clothed
by her hair, a reminder of her 30 years as a
hermit. John's fur garment recalls his
wandering in the wilderness. The rocky crags
behind them reinforce the theme of penitential
retreat. Life in the convent of the Convertite was
austere, its discipline rigorous and unrelenting.

The Trinity and the flanking figures are
looming and forceful injunctions to meditate on
sin and pray for the mercy of God. The Trinity
here takes the form known as the Throne of
Grace. Below Mary Magdalen are subsidiary
figures of Tobias and the Archangel Raphael.
They were often invoked for special protection
in fifteenth-century Florence and the Archangel
and the Magdalen were associated as healers.
In a free and flowing style, they differ in tone
and technique from the main figures. Botticelli
doubtless delegated portions of this large
painting to one or more assistants. The
altarpiece is generally dated between 1491
and 1494, when work on a new chapel is
documented. PLR

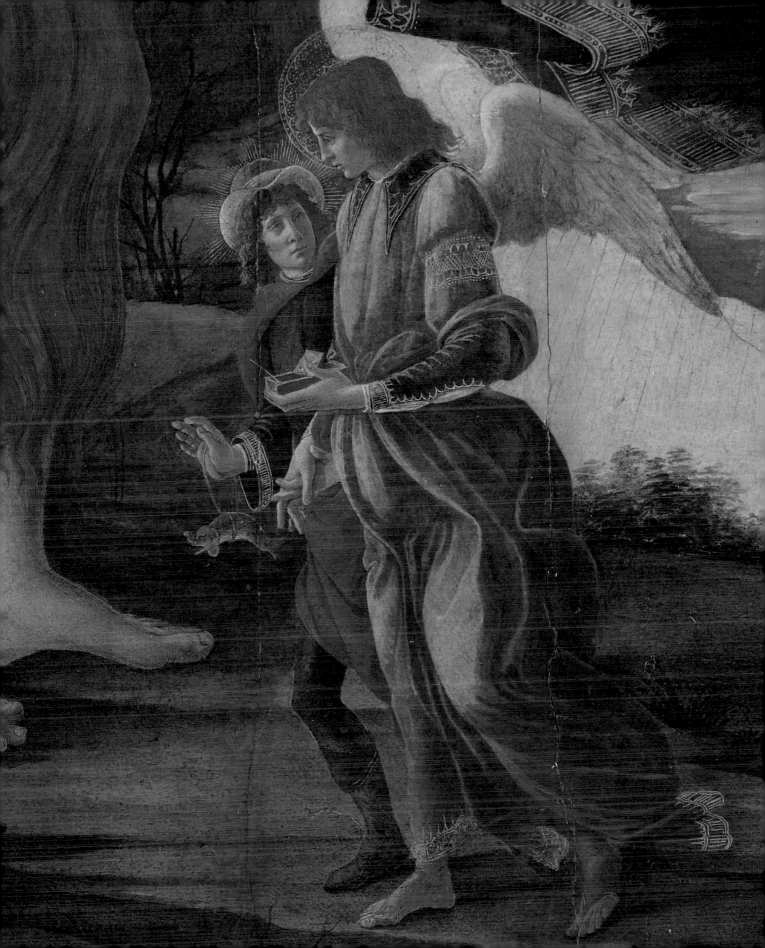

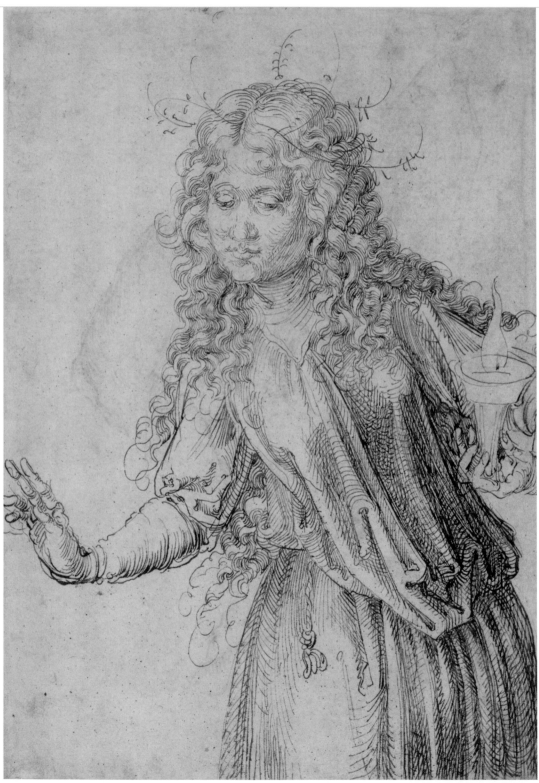

ALBRECHT DÜRER (1471–1528)
One of the Wise Virgins (recto) and
Study of Legs (verso), 1493

Pen and brown ink, on laid paper
28.9 x 20 cm
Samuel Courtauld Trust:
Princes Gate Bequest, 1978

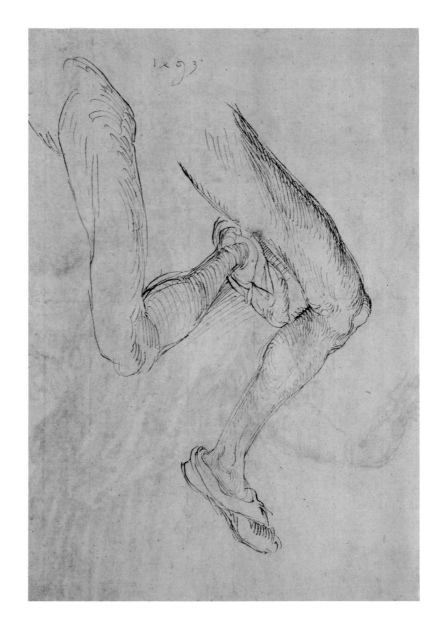

Dürer executed this remarkably ambitious
pen-and-ink drawing while he was working as
a journeyman in the region of the upper
Rhine. He used the large sheet of paper, still an
expensive material in his time, on both sides.
The main image is an elaborate study of a
single female figure, graciously bending to the
left, her arm outstretched in a salutatory
gesture. Holding a burning oil lamp and
wearing a wedding garland, her eyes lowered
in modesty, she is identifiable as one of the
exemplary figures from the biblical parable of
the Wise and Foolish Virgins.

The drawing may be understood as a
tribute to Martin Schongauer, the eminent
painter and engraver from Colmar, whom
Dürer had planned to meet but who had died
in 1491. An engraving by Schongauer is the
closest comparison for the concept of the
monumental half-figure of the Wise Virgin.
The graphic structure of densely woven layers
of curved hatches is also reminiscent of
Schongauer's style. However, Dürer's goals are
more ambitious than mere imitation. He
conceives the figure as a twisted body
challenging his own – still limited – abilities of
correct foreshortening, and in the fluent pen
lines of the garland his exquisite sense of
controlled calligraphy is clearly expressed.

The reverse with two studies of a left leg –
most probably Dürer's own – provides
remarkable evidence of his early scrutiny
of the human body. By dating the drawing
to 1493, Dürer underlines the status of the
work as a record of his own development
as a pupil of nature. SB

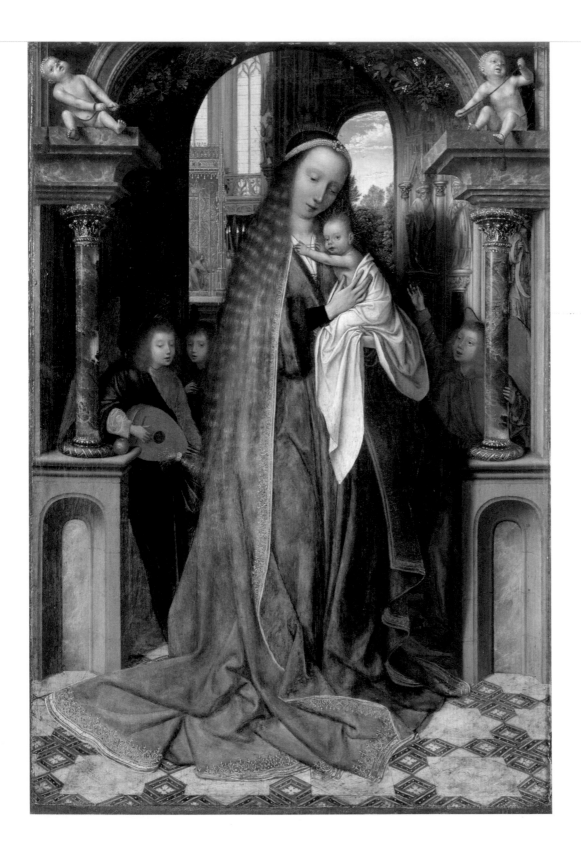

QUENTIN MASSYS
(1466–1530)
*The Virgin and Child
with Angels*, c.1500–09

Oil on panel
47.5 x 33 cm
Samuel Courtauld Trust:
Princes Gate Bequest, 1978

Relatively little is documented about the painter
Massys, save his matriculation in the Antwerp
Guild of Painters in 1491, but it is assumed that
he made several visits to Italy. Massys's
knowledge of Northern Italian painting is
manifested here in the two angels, who
energetically hold the garland of flowers above
the Virgin's head. However, this painting also
demonstrates Massys's debt to his Flemish
predecessors. The placement of Mary and her
son in a Gothic church interior is derived from
Jan van Eyck, while the typology of the Virgin's
face recalls Hans Memling.

Mary stands under an arch, crowned as if
Queen of Heaven, tenderly clasping the infant
Christ to her breast. Her hair falls loosely over
her shoulders, stressing her virginity. Mother and
child are accompanied by three young angels.
One entertains them with his lute, and another
offers a carnation to Jesus, symbolising his
mother's sorrow at his future death on the Cross.

Massys and his workshop depicted this
composition on several occasions. Closest to the
Courtauld painting is a similarly-sized panel in
the Musée des Beaux Arts, Lyon, where the
Virgin is dressed in white, further emphasising
her purity. However, the exceptional quality and
delicacy of the Courtauld *Virgin and Child*
suggest that it is the prime version. Until the
early nineteenth century it was set into a silver-
gilt jewelled altar, with 12 oval paintings placed in
the wings. Although its original location and
ownership are unknown, this suggests that
Massys's exquisite painting was appreciated both
for its high artistic quality and its devotional
significance. CMC

LUCAS CRANACH THE ELDER
(*c.*1472–1553)
Adam and Eve, 1526

Oil on panel
117.1 x 80.8 cm
Lee Bequest, 1947

Adam is shown beside the Tree of
Knowledge in the Garden of Eden,
scratching his head in indecision.
Should he accept the apple from
Eve, or obey God and refuse this
forbidden fruit? The vine by the tree
refers to Christ's second covenant
between God and Man (the New
Testament), which released
mankind from the slavery of sin to
which Adam had condemned them.
Cranach's evocation of the perfect
beauty of Paradise in the split-
second before the Fall of Man adds
poignancy to his painting. The
idealised forms of Adam and Eve,
not yet ashamed of their nakedness,
are complemented by the naturalistic
details of the animals surrounding
them, including such natural
opposites as the lion and the lamb.
 Over 50 paintings of Adam and
Eve survive by Cranach and his
workshop. This example is
particularly inventive and is the only
one not to follow either of Cranach's
two standard models for this subject.
Its original patron and setting are
unknown, but the painting's high
quality, its delicate evocation of the
natural world and the unique
iconography suggest its possible
manufacture for an associate of the
sophisticated Christian humanist
milieu of Wittenberg University. CMC

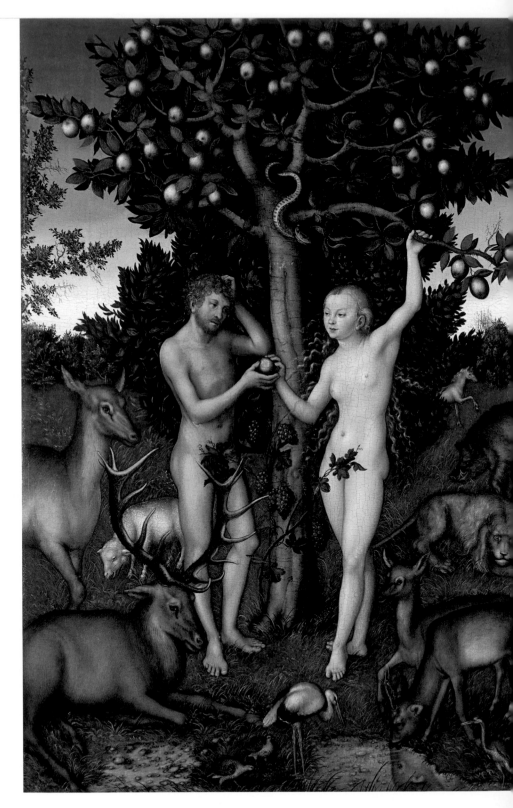

**PARMIGIANINO (GIROLAMO
FRANCESCO MARIA MAZZOLA)**
(1503–40)
Virgin and Child, c.1527–28

Oil on panel
63.5 x 50.8 cm
Samuel Courtauld Trust:
Princes Gate Bequest, 1978

Parmigianino has extended the Madonna's body
in the manner of Michelangelo's figures on the
ceiling of the Sistine Chapel in the Vatican and
framed her small head against the sky. His brush
has shaped the continuous profile of her brow
and nose with a brilliant light and set it off
against the darkness enveloping her cheek and
neck. Looking down, the Madonna appears
troubled as if she foresees the death of her son,
who in turn declines her protective gesture.
Whereas she sits beneath a canopy, reminiscent
of the curtains of an altar or tabernacle, behind
Christ a classical building lends the scene a
sepulchral air. This building has been identified
as the Septizonium, an impressive classical ruin
that Parmigianino could have studied while in
Rome between 1524 and 1527. A temple in the
form of a tower on seven floors, the Septizonium
was dedicated to the Sun and the Moon: since in
Christian thought the moon symbolised the
Virgin as *Ecclesia*, or the Church, reflecting the
light of Christ the sun, its presence here is apt.
Cut by the edges of the painting, this mysterious
tower reaches between earth and heaven.

The thinly applied paint, blocked-in areas of
colours and preliminary modelling indicate that
the painting remains unfinished. The rapidly
sketched figures reveal the elegant bravura of
Parmigianino's technique. Whereas the building
has been plotted with ruled incisions, the Virgin
has been conjured with loose brushstrokes that
suggest the presence of her body beneath the
gauzy fabrics. The presence of the isolated foot at
the lower edge of the panel shows Parmigianino
experimenting with the arrangement of the
Virgin's legs. PH

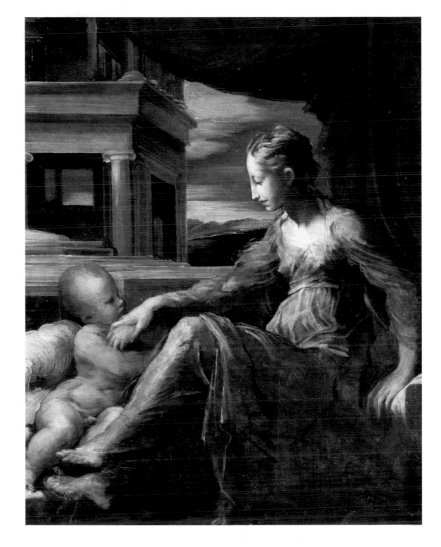

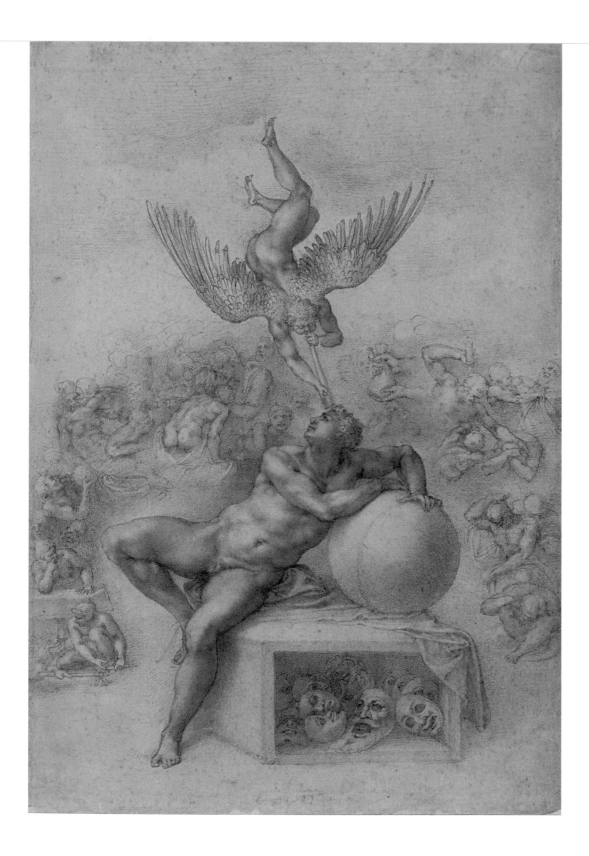

**MICHELANGELO
BUONARROTI** (1475–1564)
*The Dream of Human Life
('Il Sogno') c.*1533

Black chalk, on laid paper
39.6 x 27.9 cm
Samuel Courtauld Trust:
Princes Gate Bequest, 1978

Michelangelo was already celebrated for his god-like powers as an artist when he made this drawing in the early 1530s. The beautiful young man at the centre of the sheet is a paraphrase of his Adam in the *Creation of Man* on the ceiling of the Sistine Chapel and of a figure of Lazarus he designed for a painting of the *Raising of Lazarus* executed by Sebastiano del Piombo. His reiteration of these famous motifs expresses his own life-giving capacity.

The youth rests on a globe as he turns upwards to receive the breath of inspiration from a winged spirit hovering above him in a spiral of anatomical display. Their forms are rendered with painstaking touches of black chalk, minutely applied and smoothed over to model and modulate the flesh. Their bodies are given the effect of a stony surface – manifesting the hand of Michelangelo the

sculptor. The contours are marked out by a graceful surrounding line, which pronounces Michelangelo as the consummate master of drawing. This finished work is a deliberate statement of his artistry.

Behind the nude youth is a stormy, swirling arc of figures. They represent vices. Gluttony, lust, avarice, envy and sloth emerge and recede as disturbing, dream-like phantoms in the cloudy background. The masks in the box beneath him warn the viewer of deception. Inspiration is beset by temptation, creation is challenged as counterfeit. This drawing has been known as *The Dream* since Michelangelo's lifetime. Although he may not have given it the title, he staged its predicament with characteristically biting wit, showing us that what we see may be nothing but a dream. PLR

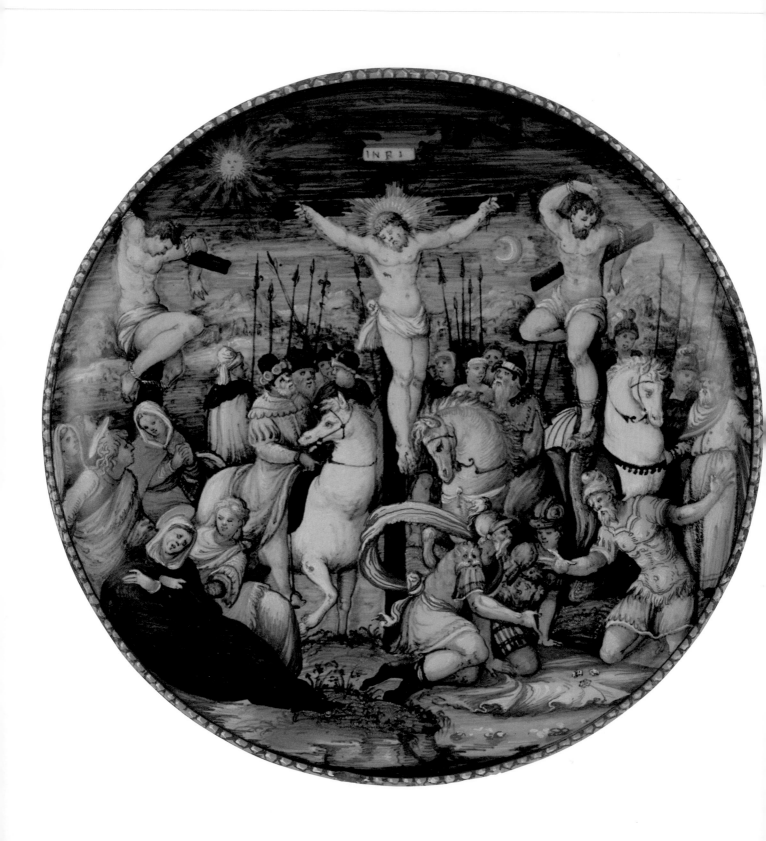

FONTANA WORKSHOP (URBINO)
Footed dish painted with the
Crucifixion, *c.*1550

Painted tin-glazed earthenware
Diameter 27 cm
Gambier-Parry Bequest, 1966

This is a superb example of the painted
tin-glazed earthenware known as maiolica,
which was produced in Italy during the
sixteenth century. It contains all the elements
that contemporaries prized in maiolica:
beautifully drawn nude figures, a complex
narrative composition and above all the skilful
use of a palette of rich, jewel-like colours.

This dish belongs to a genre of maiolica
called *istoriata*, meaning painted with stories
from the Bible or Roman history. The central
composition depicts Christ on the Cross,
traditionally shown between the two thieves
and bracketed by the sun and the moon. The
letters *INRI* in the centre refer to the Latin
for 'Jesus of Nazareth, King of the Jews'.
Christ is flanked by the Virgin and a group of
Roman soldiers dicing for his clothes. The
dramatic power of the image is heightened by
the use of colour, from the greys and blues of
the sky to the deep blue mountains and the
green, purple, blue and orange of the figures.
Red is used sparingly and is mainly reserved
for Christ's wounds. The high quality of the
painting has led scholars to attribute the dish
to Orazio Fontana, one of the most gifted
painters of the Fontana workshop.

The underside of the dish is as lavishly
decorated, with angels carrying the
Instruments of Christ's Passion. The angels
are set in dynamic motion around the central
foot, recording its probable origin as a design
by Battista Franco for a painted vaulted
ceiling in the cathedral of Urbino. AG

PIETER BRUEGEL THE ELDER
(*c.*1525–69)
Kermesse at Hoboken, 1559

Pen and ink, and black chalk
on laid paper
26.5 x 39.4 cm
Lee Bequest, 1947

Bruegel's *Kermesse at Hoboken* is a highly
detailed design for a print, later engraved
by Frans Hogenberg and published by
Bartholomeus de Mompere. The banner on
the left identifies the setting as the village of
Hoboken, known for its numerous *kermesses*,
or festivals, and often visited by the inhabitants
of nearby Antwerp, who took advantage of
the fair's entertainments and cheap beer.
Here Bruegel depicts Hoboken hosting a
number of festivities: dancing, drinking, an
archery contest and a church procession, as
well as a performance by *rederjkers*, members
of a chamber of rhetoric, at the upper left.

The year 1559, when the drawing was
executed, was a significant one for Hoboken,
as the village's ownership changed, while that
same year Philip II of Spain, ruler of the
Netherlands, decreed that *kermesses* be limited
to one day per year. *Kermesse at Hoboken* has
therefore been interpreted as an appeal to the
village's new owners to maintain Hoboken's
traditional festive calendar. However, Bruegel's
scene is not limited to positive images of
peasant festivity. A man squats at right to
relieve himself, while the central wagon
appears to be a mobile brothel. The enjoyments
and the excesses of the *kermesse* are shown side
by side. Packed with figures and independent
narratives, the drawing demonstrates Bruegel's
eye for detail and masterly control of the pen.
Yet in his depiction of the natural world, as
represented in the scene's numerous trees,
Bruegel uses a looser style, where various
types of lines, marks and blank areas
suggest depth and texture. SP

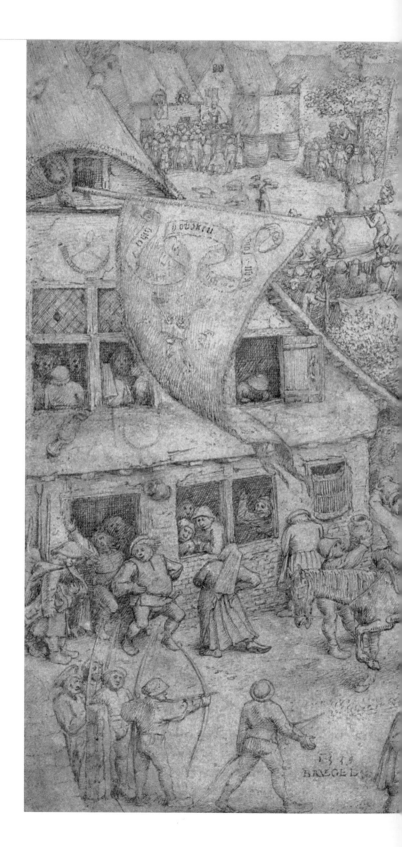

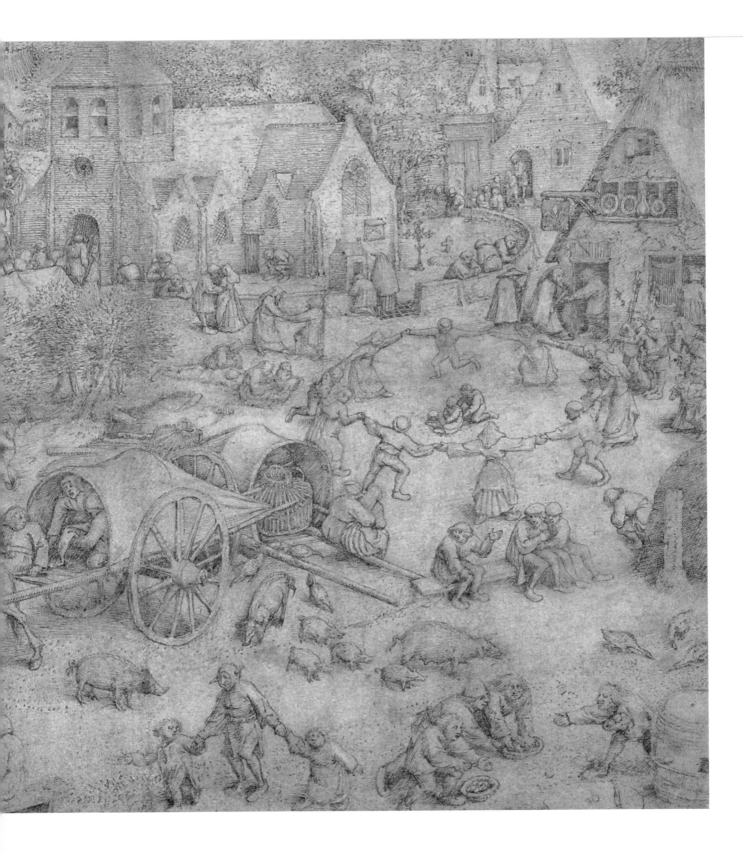

Pieter Bruegel the Elder
(c.1525–69)
Published by Hieronymus Cock
(c.1510–70)
The Rabbit Hunt, 1560

Etching
22.2 x 29.1 cm
Samuel Courtauld Trust:
Princes Gate Bequest, 1978

The title of the print derives from the action taking place in the right foreground of Bruegel's panoramic landscape, where a hunter is training his crossbow at a group of rabbits. It has been argued that this scene may be related to a Dutch proverb, roughly translated as: 'He who pursues two rabbits at once will lose both.' However, this reading is complicated by the fact that there is a second figure, who holds a spear and is approaching the man with the crossbow from behind a tree. Here the hunter is himself being hunted. Both the rabbits and the man with the crossbow appear unaware of their impending doom. Bruegel creates a circle of hide-and-seek, revolving around the tree at right, exploiting the tension between ignorance and knowledge, action and inaction.

The Rabbit Hunt is the only print executed by Bruegel himself. Unlike the production of an engraving, which requires specialist training, the etching technique is very similar to drawing, which allowed Bruegel to transfer his loose graphic style directly to the copper plate. Variations in lines and dashes indicate differences of light and texture in his rendering of fields, shoreline and trees, contrasting with the more detailed and tight depiction of buildings and the foreground figures. SP

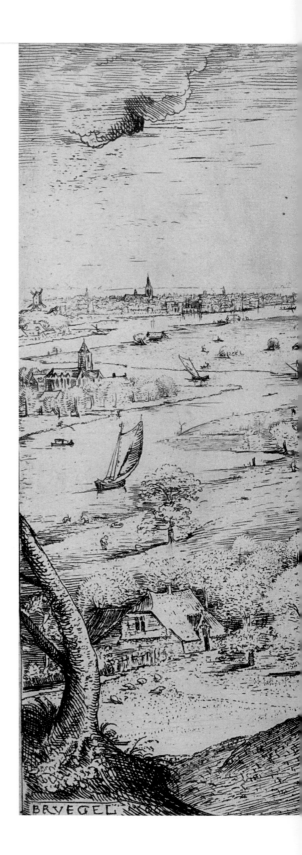

PIETER BRUEGEL THE ELDER
(*c.*1525–69)
*Landscape with the Flight
into Egypt*, 1563

Oil on panel
37.1 x 55.6 cm
Samuel Courtauld Trust:
Princes Gate Bequest, 1978

This work transposes the story of the Holy
Family fleeing persecution in Egypt to an
imaginary northern landscape with a broad
river valley bordered by dramatic craggy peaks.
In his biography of Pieter Bruegel, published
in 1604 as part of the *Schilder-boeck*, Karel van
Mander wrote, 'it is said that while he was in
the Alps he swallowed all those mountains and
rocks which, upon returning home, he spat out
again onto canvases and panels, so faithfully
was he able, in this respect and others, to
follow Nature'. Although it is plausible that in
creating this work Bruegel may have drawn on
his experience crossing into Italy around
1551–52, the high viewpoint, panoramic effect
and use of bands of colour to separate the
foreground from the distance are conventions
of a landscape painting tradition that would
soon evolve into a more naturalistic approach.
Bruegel would himself contribute fully to
these innovations.

The dramatic landscape and abundant
detail serve to enhance the religious narrative.
At the lower left travellers struggling over a
narrow footbridge emphasise the perilous
nature of the journey undertaken by the Holy
Family. The idol seen tumbling from its shrine
in a pollarded willow symbolises the defeat of
paganism by the arrival of Christ. Bruegel may
have painted this work for one of his principal
patrons, Cardinal Antoine Perrenot de
Granvelle, counsellor to the regent of the
Netherlands, in whose inventory it is recorded
in 1607. In the seventeenth century it was
owned by Rubens and subsequently by the
Antwerp collector Pieter Stevens. EV

PETER PAUL RUBENS (1577–1640)
The Decent from the Cross, 1611 (centre)
The Visitation, 1613 (left)
The Presentation, 1613 (right)

Oil on panel
115.2 x 76.2 cm (centre)
83.2 x 30.3 cm (left)
83 x 30.4 cm (right)
Lee Bequest, 1947 (centre)
Princes Gate Bequest, 1978 (side panels)

In 1608 Rubens returned to Antwerp after
a period of intense work and study in Italy.
Immediately after this he produced some
of his most energetic and enervating work,
adapting and melding what he had learnt from
the art of the past and present in Italy into his
own distinctive and bold style. Perhaps the
culmination of this period was the prestigious
commission Rubens received in 1611 for a large
winged altarpiece for the chapel of the
Arquebusiers Guild (members of the civic
guard) in Antwerp Cathedral. The Descent
from the Cross was selected as the subject of
the central panel.

This unusually large and highly finished
sketch is probably the preliminary painting or
modello for the Descent, which Rubens
presented for the Guild's approval before
undertaking work on the final altarpiece. It
depicts Christ's grieving followers removing
his broken and lifeless body from the Cross. At
the bottom of the composition, St John the
Evangelist, dressed in eye-catching red, directs
attention to the tearful women preparing to
receive Christ's corpse. Rubens has placed
Christ's foot on Mary Magdalen's shoulder to
contrast his dead pallid flesh with the robust
living woman. Dressed in dark blue, the Virgin
Mary reaches to touch her son, adding to the
pathos and restrained but intense emotion of
the scene.

Two slightly later oil sketches for the wings
of the altarpiece, representing the Visitation of
Mary to Elizabeth and the Presentation of the
Infant Christ in the Temple (illustrated here),
are also in the Gallery's collection. CMC

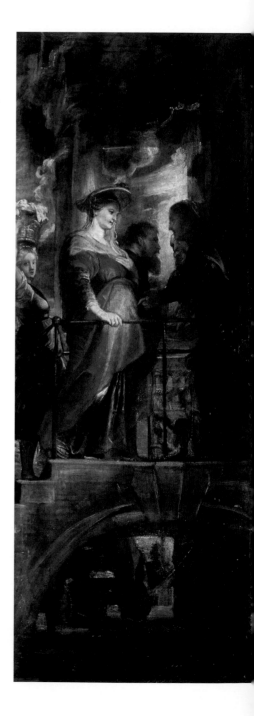

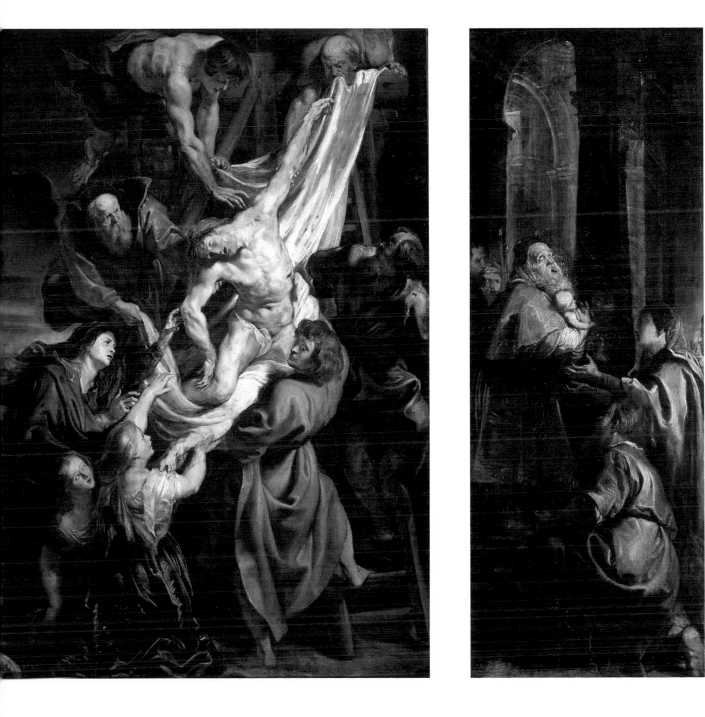

PETER PAUL RUBENS (1577–1640)
*The Family of Jan Brueghel
the Elder, c.1613–15*

Oil on panel
124.5 x 94.6 cm
Samuel Courtauld Trust:
Princes Gate Bequest, 1978

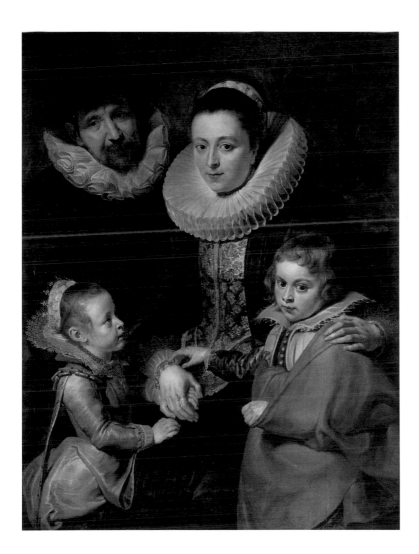

This painting is testament to a deep artistic friendship. Rubens worked extensively with Jan Brueghel the Elder (1568–1625), a son of the famous Pieter Bruegel the Elder. The pair collaborated on many works, to which Rubens contributed the figures, and Jan Brueghel the plants and animals. Rubens also assisted Brueghel in the latter's correspondence with his Milanese patron, Cardinal Federigo Borromeo.

Rubens's portrait depicts Brueghel with his family: his second wife Catharina van Marienberg, and their children Pieter (born 1608) and Elisabeth (born 1609). Unusually for this date, the wife, Catharina, rather than her husband, dominates the picture. She is flanked by her son and daughter, whom she draws closely towards her. One hand encircles Pieter's shoulder, while the other clasps Elisabeth's delicate fingers. Elisabeth gazes lovingly at her mother, whom she would be expected to emulate, and her elegantly dressed brother draws the viewer's attention to Catharina's precious bracelet, perhaps a betrothal gift. No sign of Jan Brueghel's profession is given. He and his family are dressed as wealthy Antwerp burghers.

Jan Brueghel's kindly features look towards his wife and young family. It has been suggested that the painting was conceived originally as a portrait of Catharina and her children: Jan is absent from an early copy, and he sits somewhat unsymmetrically in the otherwise balanced composition. However, Rubens has managed to integrate his friend successfully into his painting. Jan's pose, standing protectively behind his family, further enhances the unusual intimacy of this touching family portrait. CMC

PETER PAUL RUBENS (1577–1640)
Landscape by Moonlight, c.1635–40

Oil on panel
64 x 90 cm
Bought in 1981 by the Samuel Courtauld
Trust from the estate of Count Antoine
Seilern with the assistance of the National
Heritage Memorial Fund and the MGC/V&A
Purchase Grant Fund

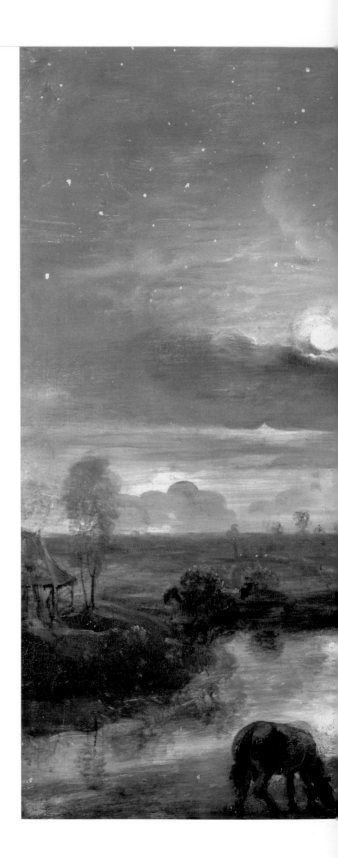

Towards the end of his life Rubens bought a
country estate, Het Steen, and retired there
whenever possible with his young second wife,
Helena Fourment, and their growing family.
Some of his most celebrated landscapes were
painted in those last years, apparently for his
own pleasure, among them this unique moonlit
view. The peaceful countryside, inhabited only
by a grazing horse, is dominated by the bright
moon casting its reflection on water, bathing the
earth and trees and illuminating the clouds in a
sky pierced by brilliant stars.

The creation of this painting was
surprisingly laborious, as technical examination
has revealed. The original picture was smaller
and more highly finished; at some point it
contained a hastily-sketched group with a
mother and child, perhaps the Holy Family,
seated by a fire at the foot of the foremost tree.
The composition was then enlarged on panels
added to the top and right sides. Groups of
rapidly drawn figures, some suggesting nymphs
and satyrs, as well as a bright lantern, have been
detected beneath the paint surface on the right,
their presence and Rubens's purpose no longer
explicable. The horse, added at one of these
intermediate stages, is the only living creature
to remain. A contemporary print confirms the
finished appearance of Rubens's work.

In England by the eighteenth century, the
painting was praised by its owner, Sir Joshua
Reynolds, in his Royal Academy Discourse of
1778. Admired by artists such as Gainsborough
and Constable, it contributed to Rubens's
influence on the British school of landscape
painting. HB

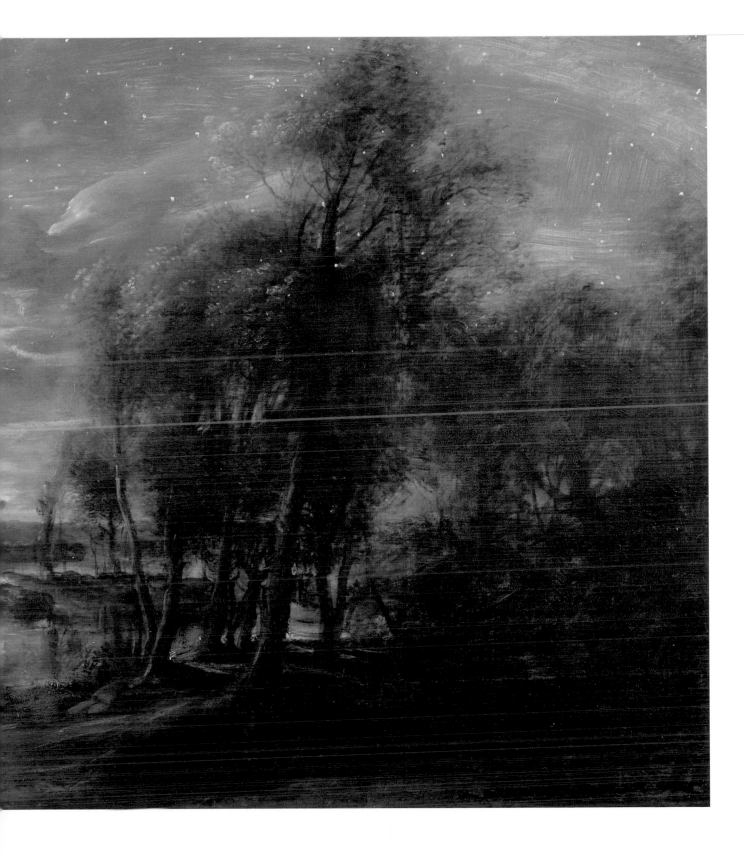

PETER PAUL RUBENS (1577–1640)
Helena Fourment, c.1630–31

Black and red chalk heightened with white,
pen and brown ink (possibly including later
retouchings) on laid paper, the figure cut
round in silhouette and backed
61.2 x 55 cm
Samuel Courtauld Trust:
Princes Gate Bequest, 1978

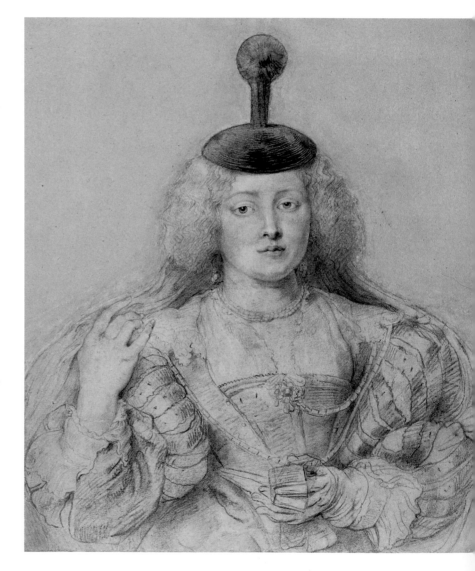

In this stunning portrait of monumental scale Rubens presents his young wife, Helena Fourment, whom he married in 1630, after having been a widower for four years and not yet being 'inclined to live the abstinent life of the celibate'. In the ten years of their happy marriage five children were born, and Rubens never ceased to celebrate Helena's beauty in his work. The drawing – probably executed shortly after the wedding – gives exceptional proof of this.

Clad in an opulent dress adorned with fine jewellery, Helena gracefully raises her right hand to draw aside the *huke*, a fashionable long all-weather garment, fixed to a striking tasselled cap. Deriving from the classical *pudicitia* (piety) motif, this gesture expresses not only elegance but also modesty and chastity, the latter being underlined by the small prayerbook Helena is holding in her gloved left hand. As her index finger is placed inside the book, she is depicted as being interrupted in her reading, stressing her piety. Subtle contrasts animate the work, such as the juxtaposition of one bare and one gloved hand, or of the figure's smoothly lit left side and the shaded right. The ingenious use of different coloured chalks – most astonishing in the eyebrows, one of which is red, the other black – and the employment of the paper colour as a mid-tone shows the exceptional refinement of Rubens's mastery of the medium. The drawing's high finish speaks strongly for its function as an independent work rather than a preparatory drawing. SB

REMBRANDT VAN RIJN (1606–69)
Saskia with One of Her Children,
c.1635–38

Red chalk, on laid paper
14.1 x 10.6 cm
Samuel Courtauld Trust:
Princes Gate Bequest, 1978

This spontaneous drawing affectionately
captures a private domestic scene showing
Rembrandt's wife, Saskia Uylenburgh
(1612–42), in bed with an infant in her arms.
After their marriage in June 1634 the life of the
couple was cruelly affected by Saskia's frequent
illness and the death of their first three children
in infancy: Rumbartus, baptised in December
1635, lived for only two months; two girls, both
called Cornelia, baptised in July 1638 and 1640,
died after a few weeks. Only Titus, born in
September 1641, reached adulthood.

 Although it is unclear which child is
depicted, the use of red chalk – a medium that
Rembrandt mostly used in the 1630s – and the
drawing style suggest an early date. Typical of
the young Rembrandt is the juxtaposition of
regular parallel hatches softly modelling
Saskia's right shoulder and head, dense zigzag
strokes indicating the shadowed area above,
and vigorous lines in the foreground,
suggesting a blanket or sheet. This motif,
swiftly sketched as an afterthought, obstructs
the immediate view on to the figures and
heightens the intimacy of the peaceful scene.
The drawn bed curtain on the left acts to frame
and reveal the group of mother and child,
composed in pyramidal form, as an image of
timeless quality. The light falling from the right
onto Saskia's contented face enlivens the figure
and – together with her gently leaning posture
– expresses *naetuereelste beweechgelickheijt*,
most natural movement. This, according to a
statement Rembrandt made in a letter of 1639
to the poet Constantijn Huygens, was the aim
of his art. SB

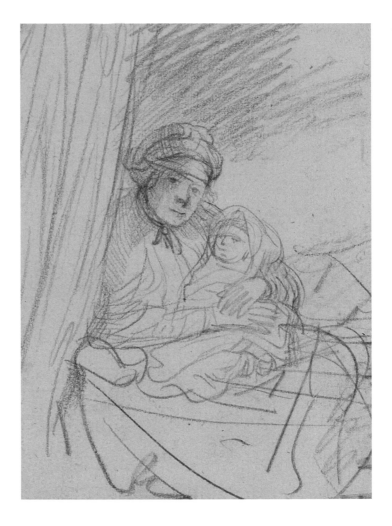

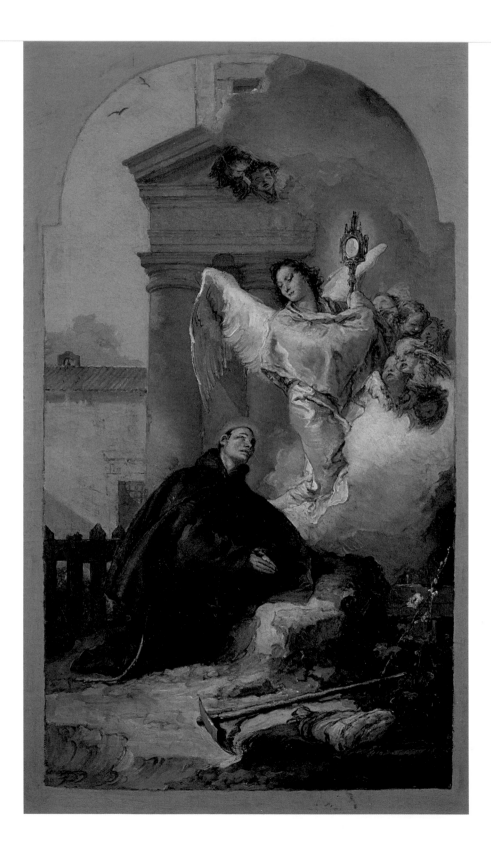

GIOVANNI BATTISTA TIEPOLO
(1696–1770)
*St Pascual Baylon's Vision
of the Eucharist*, 1767

Oil on canvas
63.6 x 38.7 cm
Samuel Courtauld Trust:
Princes Gate Bequest, 1978

GIOVANNI BATTISTA TIEPOLO
(1696–1770)
Study for *St Pascual Baylon's
Vision of the Eucharist*, c.1767

Red and white chalk on blue-grey paper
31.4 x 25.1 cm
Samuel Courtauld Trust:
Princes Gate Bequest, 1978

Tiepolo was the last of the great Venetian painters.
Although a product of his time, he worked more
in the manner of his great sixteenth-century
predecessors such as Veronese than that of any
of his contemporaries.

In 1762 the elderly artist and his sons travelled
to Spain to decorate the new Royal Palace in Madrid.
King Charles III subsequently commissioned him
to produce a set of seven altarpieces for a new
church for the friars of the Discalced (Barefoot)
Franciscans at Aranjuez. For this project Tiepolo
was asked to produce small painted models,
allowing the monarch and his confessor to approve
the designs.

This is Tiepolo's oil sketch for the painting
above the high altar. Appropriately it depicts Pascual
Baylon, the patron saint of the Aranjuez church.
This sixteenth-century Spanish nobleman became a
Franciscan and, in the manner of St Francis, piously
took on humble tasks. Tiepolo depicts him
interrupted in his work, his tools abandoned at his
side. Pascual looks ecstatically towards a richly clad
angel bearing the Eucharistic Host, set in an ornate
monstrance. The Gallery also posseses Tiepolo's
preparatory drawing for this detail. The painting is
remarkable for its freshness and speed of execution
and its convincingly naturalistic details (such as the
light falling on the building in the background).
These heighten the contrast between Pascual's
human world and the bright, bejewelled colours of
his heavenly vision. Such qualities were less evident
in the finished altarpiece (now destroyed), perhaps
because they were felt not to revere sufficiently
the monastery's dedicatory saint. However, the
surviving oil sketch does full justice to Tiepolo's
original artistic vision. CMC

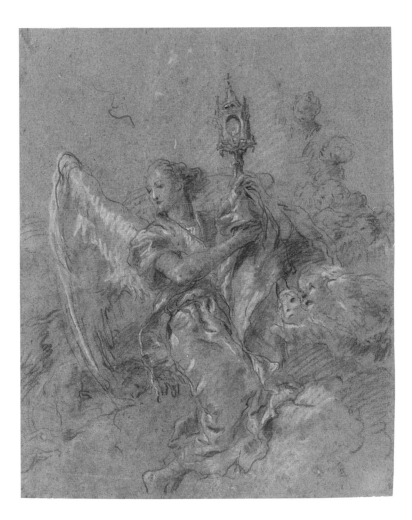

Thomas Gainsborough (1727–88)
*Portrait of Mrs Margaret
Gainsborough, c.1778*

Oil on canvas
76 x 64 cm
Samuel Courtauld Trust:
Courtauld Gift, 1932

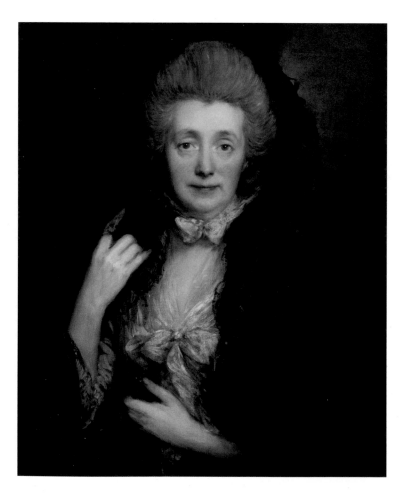

Margaret Burr, the illegitimate daughter of Henry,
3rd Duke of Beaufort, was born around 1728. In 1745
she began to receive an annual income of £200 from
her late father's estate. Ten months later she married
the nineteen-year-old painter Thomas Gainsborough.
Her income and connections would help
Gainsborough to establish his artistic career, while
she in turn played a boisterous role in managing his
business. Margaret's financial means enabled
Gainsborough to cast himself as both the hen-pecked
husband and as an artist who worked for love rather
than money.

The play between tenderness and frankness
characterises Gainsborough's portrait of his wife.
The portrait's bust-length format helps establish the
sense of intimacy between the sitter and her
artist/viewer. This effect is enhanced by the
unusually direct gaze with which she confronts us.
Margaret Gainsborough is shown drawing aside her
shawl. This play between exposure and enclosure
extends to the hands themselves as, in turn, they pull
at and play with the shawl in a pose of simultaneous
veiling and unveiling.

Gainsborough's loose brushwork lends the work
an appearance of spontaneity, which conceals the
likely source of Margaret's pose. In the eighteenth
century this portrait format was celebrated as
signifying the fidelity, assistance and imperiousness
that Roman empresses offered their husbands. This
would have been a fitting reference: Gainsborough
made a dramatic re-entrance into the London art
world in the late 1770s, to huge acclaim from critics,
who perceived a supreme new mastery in his work.
Mrs Margaret Gainsborough is an appropriate image
of Gainsborough's consort, produced by an artist
reaching the peak of his artistic prowess. SM

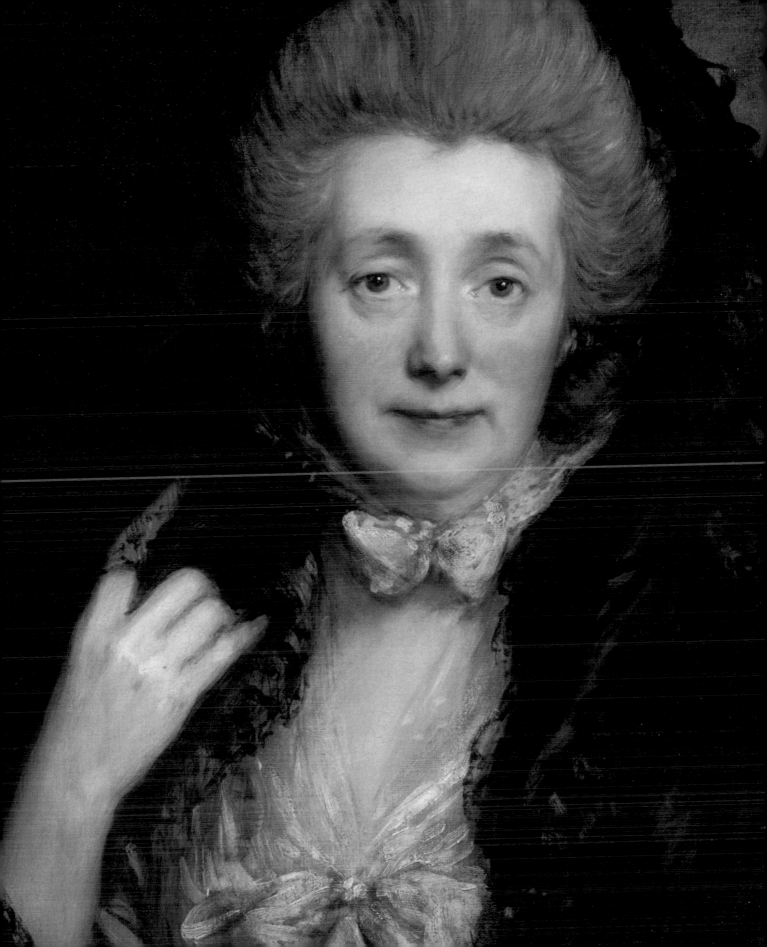

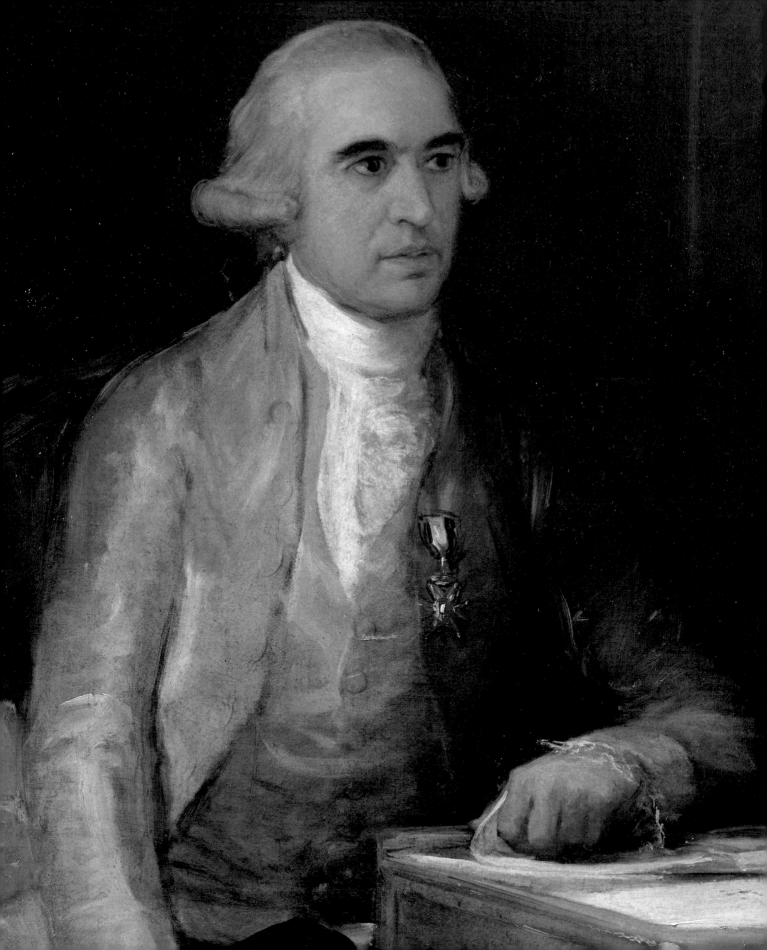

FRANCISCO DE GOYA (1746–1828)
Don Francisco de Saavedra, 1798

Oil on canvas
200.2 x 119.6 cm
Lee Bequest, 1947

Francisco da Saavedra was a friend of the
Spanish liberal Gaspar de Jovellanos, one
of Goya's most consistent supporters and
admirers. In November 1797, as a result of
Jovellanos's influence, Saavedra was appointed
Minister of Finance to Charles IV of Spain.
At the same time Jovellanos became Secretary of
State. Their tenure of these important posts was
brief. Both were opponents of the Queen's
favourite, Manuel Godoy, and in August 1798
they virtually disappeared from public life.
Saavedra was formally dismissed the
following February.

This canvas was commissioned in the
spring of 1798, while Goya was engaged on a
portrait of Jovellanos (now in the Museo del
Prado, Madrid). It was probably made later that
year, in commemoration of Saavedra's ministry.
The portraits of the two friends and political
allies are closely related. In both paintings the
sitter faces to the right and is seated on
apparently the same round-backed chair before a
table. But while the Prado painting shows
Jovellanos resting his elbow on this table,
Saavedra is represented in more active mode. He
sits upright, as if about to rise from his desk,
which is covered with official papers and an ink-
well. The simplicity of the background, very
different to the rich decoration of Goya's portrait
of Jovellanos, appears influenced by the painter's
awareness of eighteenth-century English
portraiture. However, it could also have been
chosen by the sitter, who was renowned for his
integrity and in particular, as a contemporary
noted, for the 'well-regulated' and 'English'
character of his household. CMC

JOSEPH MALLORD WILLIAM TURNER
(1775–1851)
Dawn after the Wreck (also known
as *The Baying Hound*), *c.*1841

Watercolour, red chalk and bodycolour
over pencil, on laid paper
25.1 x 36.8 cm
Samuel Courtauld Trust:
Stephen Courtauld Bequest, 1974

This powerfully evocative watercolour
was immortalised by John Ruskin, the art
critic and illustrious champion of Turner,
who interpreted the scene as an elegiac
lament on the destructive powers of the
sea. 'One of the saddest and most tender
[of Turner's works]', he wrote in *Modern
Painters* (vol. v, 1860), 'is a little sketch of
dawn, made in his last years. It is a small
space of level sea shore; beyond it a fair,
soft light in the east; the last storm-clouds
melting away, ... ; some little vessel – a
collier, probably – has gone down in the
night, all hands lost; a single dog has
come ashore. Utterly exhausted, ... it
stands howling and shivering. The dawn
clouds have the first scarlet upon them, a
feeble tinge only, reflected with the same

feeble bloodstain on the sand.' For
Turner, according to the author, scarlet
symbolised death and destruction.

Although Ruskin no doubt reads
more into the work than Turner
intended, his eloquent description,
combining the effects of nature with
dramatic narrative, echoes the artist's
painterly skills. The location is most
probably Margate, as the drawing closely
resembles an oil painting of 1840, *The
New Moon*, which depicts the onset of
dusk at this Kent coastal resort, where
Turner spent an increasing amount of
time in the 1840s. Ruskin's title for the
drawing is inaccurate, since the
distribution of light indicates the effects
of sunset rather than sunrise. JS

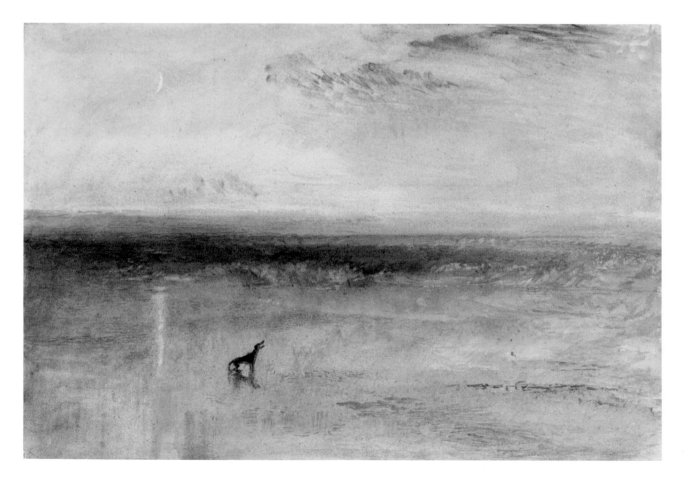

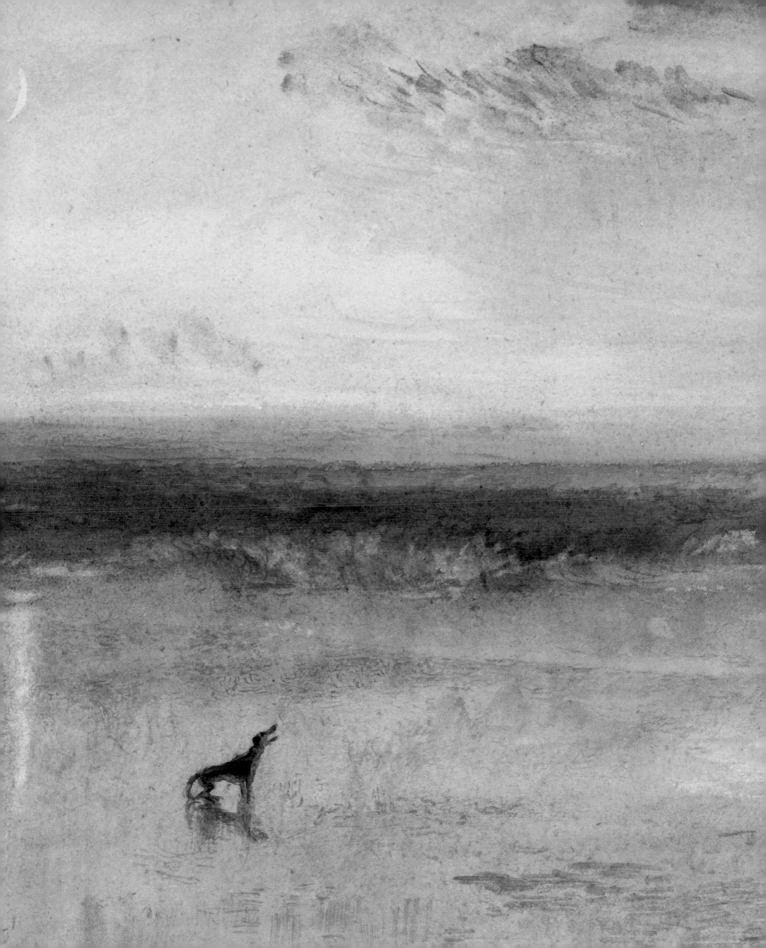

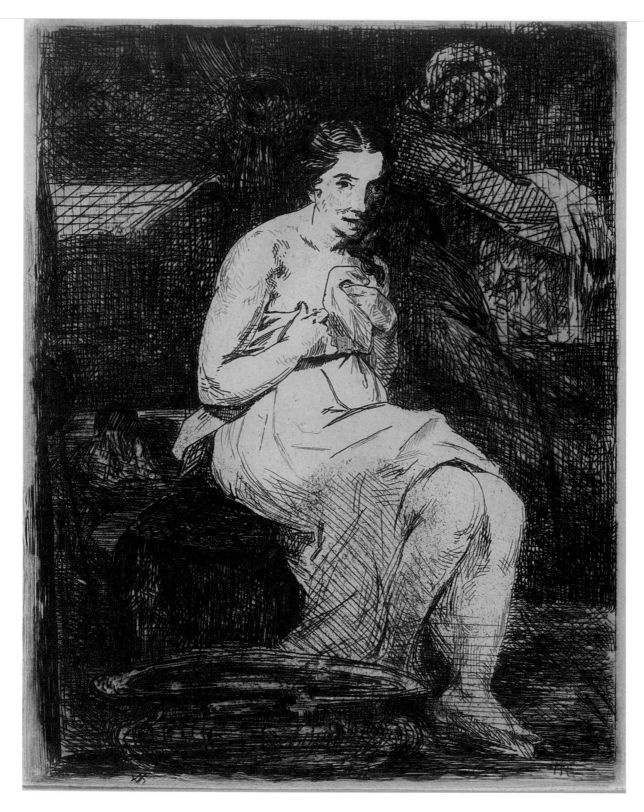

EDOUARD MANET
(1832–83)
La toilette, 1860–61

Etching, second state, 1905
28.4 x 22.4 cm
Samuel Courtauld Trust:
Courtauld Gift, 1935

EDOUARD MANET
(1832–83)
La toilette, 1860–61

Red chalk
29 x 20.8 cm
Samuel Courtauld Trust:
Courtauld Bequest, 1948

In this intimate scene a seated woman modestly hides her nakedness from the prying eyes of both her maid and the viewer. The image of a woman watched while bathing relates thematically to several paintings on which Manet worked around 1860, notably *Nymphe surprise* (Museo Nacional de Bellas Artes, Buenos Aires). The life model for these works was most probably Suzanne Leenhoff, whom Manet later married, while the compositional treatment was largely inspired by Old Master paintings and prints. The presence of a maid and the pose of the seated nude recall the biblical story of Bathsheba, particularly as depicted in works by Rembrandt and Rubens, and connections have been made with engravings after Giulio Romano (1499–1546). The Courtauld collections also include a preparatory drawing for this print in red chalk, with outlines clearly traced through to transfer the design to the copper plate for etching.

Manet's etching technique is exceptionally vigorous, the boldly contrasting light and shade reminiscent of Rembrandt's lighting effects. Largely wiped clean of ink, the whitened female form looms out from the dark, impenetrable surroundings formed by a web of deeply bitten cross-hatched lines. Since most of Manet's early prints were copies of his paintings, it seems probable, from the elaborate background details seen in the etching but not in the preparatory drawing, that it was made after a painted image, since lost. JS

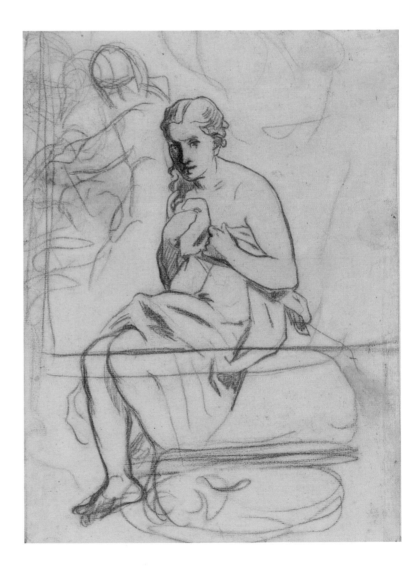

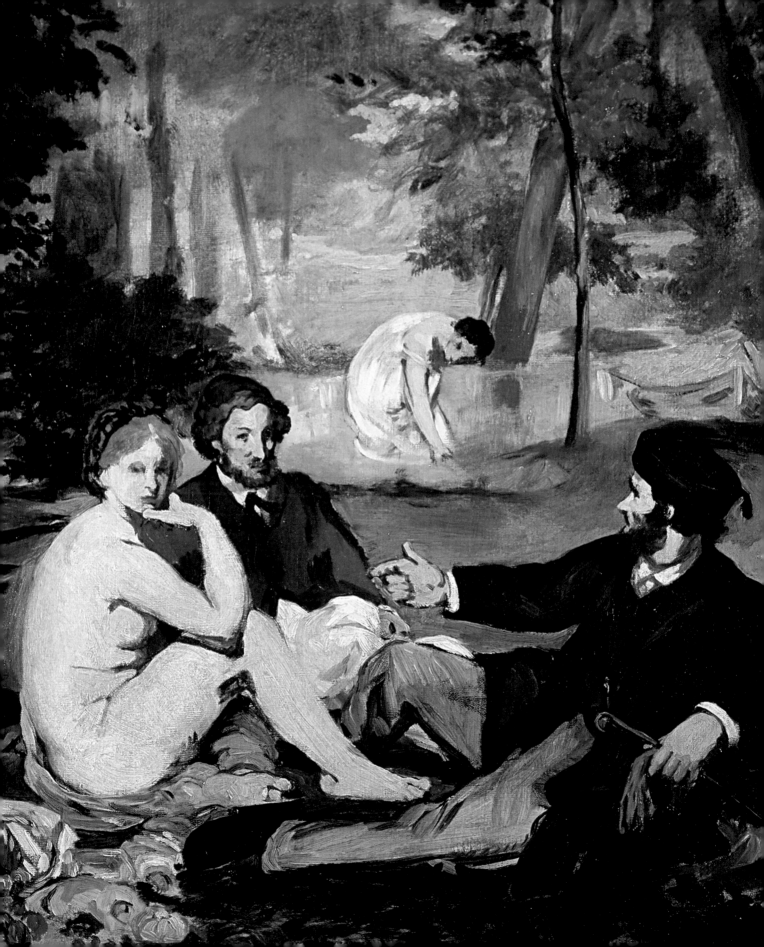

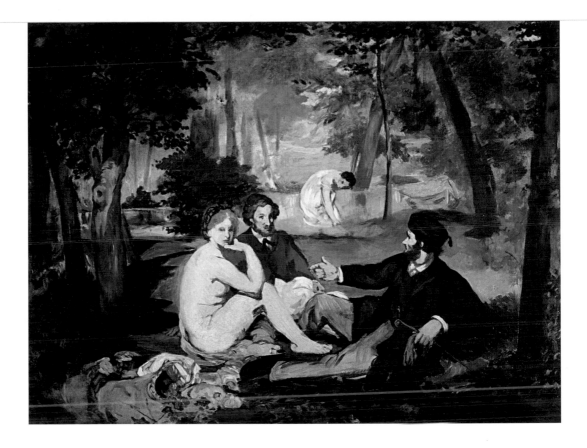

EDOUARD MANET
(1832–83)
Le Déjeuner sur l'herbe,
*c.*1863–68

Oil on canvas
89.5 x 116.5 cm
Samuel Courtauld Trust:
Courtauld Gift, 1932

This is a smaller version of Manet's *Déjeuner sur l'herbe,* rejected by the Salon jury in 1863 and exhibited at the Salon des Refusés. Manet aimed to rework the theme of the Titian/Giorgione *Concert champêtre* in the Louvre in a more luminous, outdoor ambience, but he executed the final painting in the studio, deriving the poses of the figures from a group of nymphs and river gods in an engraving by Marcantonio Raimondi after Raphael's lost *Judgement of Paris.*

The large painting was much criticised. The juxtaposition of a naked woman with men in modern dress was regarded as indecent, and the woman's body was seen as ugly. It was also unclear what type of subject it was: it looked like a parody of contemporary academic 'high' art,

presenting a scene from bohemian life on the heroic scale of history painting. Moreover, the gaze of the naked woman, looking directly at the viewer, made it impossible to view the scene as taking place in some sylvan glade of the imagination.

X-ray examination of both paintings has shown that the Courtauld version is a replica of the large canvas, since it shows no significant changes during its execution, whereas the large version was much altered: it originally included an open vista in the background. The first owner of the Courtauld canvas was Manet's friend the Commandant Lejosne; it seems likely that Lejosne asked the artist to make this reduced version. JH

EDOUARD MANET (1832–83)
Banks of the Seine at Argenteuil,
1874

Oil on canvas
62.3 x 103 cm
On loan from a private collection

Banks of the Seine at Argenteuil was painted while Manet was visiting Monet at Argenteuil in the summer of 1874; the models were probably Monet's wife, Camille, and his son Jean. Manet had refused to participate in the Impressionists' first group exhibition earlier that year, preferring to continue showing at the Salon, but he was on close personal terms with Monet.

The picture's broken brushwork and vivid, variegated colour marks Manet's closest approach to Monet's open air Impressionism; it was probably (in part, at least) painted out of doors. But comparison with Monet's *Autumn Effect at Argenteuil* (pp 74–75) reveals important differences. Manet used clear black paint for certain points in the composition and did not pay close attention to the appearance of reflections in water, whereas Monet's

reflections were always closely observed, directly below the objects reflected. Nor did Manet systematically indicate the direction of the sunlight; we have little idea of how the light is falling on the figures.

Manet was primarily concerned with figure subjects, with depicting the unexpected groupings of modern people in their surroundings. The main focus of the picture is the figures, standing inexpressively on the riverbank. There is a tension between the formal organisation of the canvas and its evocation of modernity. Its broken rhythms and staccato focuses can be interpreted as suggesting the nature of everyday experience in the modern world, but the rhythms of the forms can also be seen as showing a preoccupation with formal qualities, detached from any representational purpose. JH

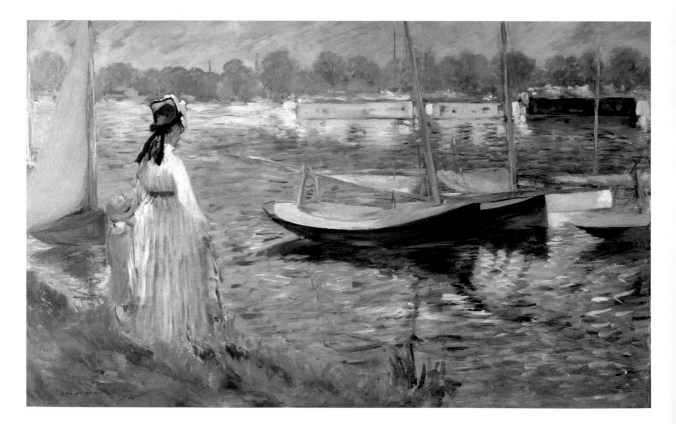

EDOUARD MANET (1832–83)
A Bar at the Folies-Bergère,
1881–82

Oil on canvas
96 x 130 cm
Samuel Courtauld Trust:
Courtauld Gift, 1934

A Bar at the Folies-Bergère was Manet's last major
painting, exhibited at the Paris Salon in 1882. He
made sketches in the Folies-Bergère itself, but the
final painting was executed in his studio, using as a
model a barmaid who worked in the establishment.

In the preliminary oil study the barmaid's head
is turned towards the right, and the reflections in the
mirror behind the bar are placed in an intelligible
position. Here, though, she looks out towards the
spectator from the centre of the picture, while her
reflection has been displaced to the right, and her
customer appears in reflection in the extreme top
right of the canvas. There is a dislocation between
her close encounter with the man seen in the mirror
and her distance and abstractedness from the viewer.

These reflections cannot be logically understood.
X-rays of the painting show that initially its forms
were close to those in the study; the discrepancies
between the principal image and the reflections were
introduced during the execution of the picture, and
were thus quite deliberate. These distortions would
have seemed all the more unexpected to nineteenth-
century viewers. Manet consistently avoided readily
legible compositions, in order to convey a vivid sense
of actuality. The composition of *A Bar at the Folies-
Bergère* was his most extreme dislocation of
perceived reality.

The Folies-Bergère was a popular place of
entertainment for fashionable figures in Parisian
society and for the *demi-monde*, and prostitutes plied
their trade openly there. The status of the barmaids
was ambivalent: they were primarily there to serve
drinks, but they themselves were also potentially
available to their clients. Manet's picture, with its
wilful distortion of perceived experience, seems
designed to enshrine this uncertainty. JH

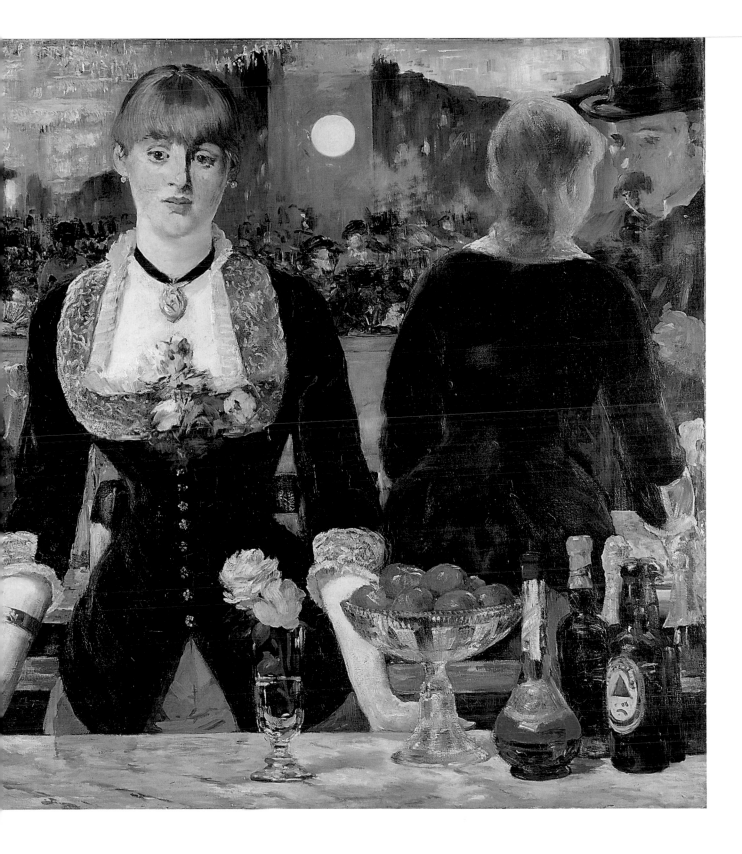

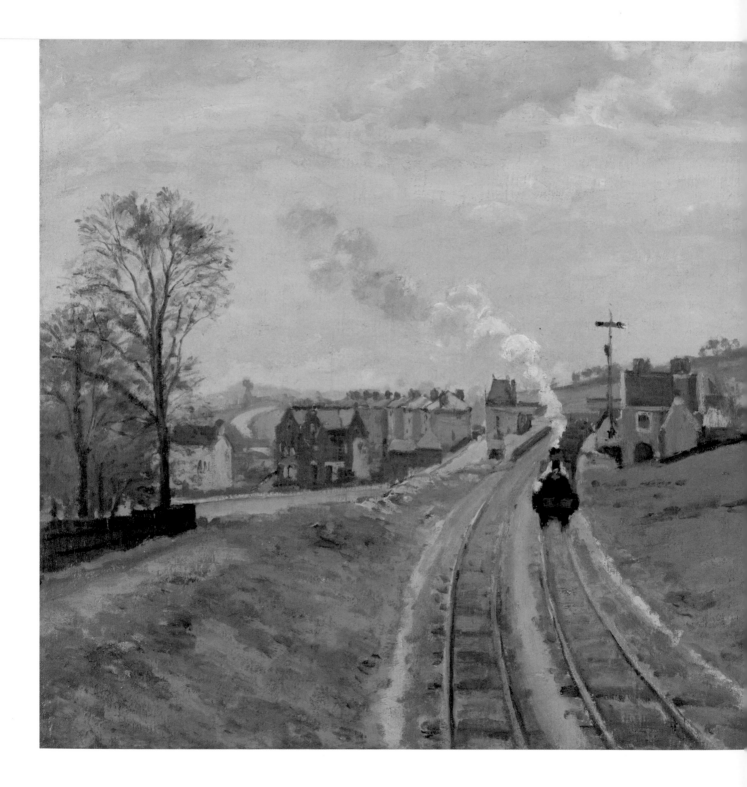

CAMILLE PISSARRO (1830–1903)
Lordship Lane Station, Dulwich,
1871

Oil on canvas
44.5 x 72.5 cm
Samuel Courtauld Trust:
Courtauld Bequest, 1948

Pissarro painted this picture while living in London
as a refugee from the Franco-Prussian war in
1870–71. It represents Lordship Lane Station (now
demolished) on the old Crystal Palace (High-Level)
railway, seen from a footbridge to the south of
the station. The line catered for the crowds coming
to the Crystal Palace, a popular recreation and
exhibition centre after its reconstruction at
Sydenham in 1852–54. The scene shows a modern
landscape in the making, with the rows of new
houses on either side of the station punctuated
by still-undeveloped open land. The chosen subject
is deliberately anti-picturesque, with the rough
slopes and drab fences framing the central motif
of tracks and train.

This seems to be the first occasion on which
one of the Impressionist group made a train into
his central motif. It may echo Turner's *Rain, Steam
and Speed*, which Pissarro saw in the National
Gallery in London, but Pissarro adopted a far
more detached view, closer in its treatment to
contemporary topographical prints of the new
railway landscape.

The picture is quite subdued in colour; the
effect of an overcast day is evoked by varied greens
and soft red-browns, with the white of the smoke
and the clear black of the engine as a central focus.
This comparatively tonal treatment is in marked
contrast to the lavish colour that Monet began to
use soon afterwards in sunlit scenes (see pp 74–75)
and to the multicoloured interplay of touches which
Pissarro himself later adopted. JH

CLAUDE MONET
(1840–1926)
Autumn Effect at Argenteuil,
1873

Oil on canvas
55 x 74.5 cm
Samuel Courtauld Trust:
Courtauld Gift, 1932

At this period Argenteuil was rapidly expanding, as an industrial town and as a centre for recreational sailing (see pp 68–69). Often Monet presented the contemporary facets of the place, but here it appears as if timeless, a few houses presided over by a church spire, framed by the sunlit trees, seen from a branch of the river Seine; the blue stripe running across the canvas below the buildings represents the main channel of the river.

Of all Monet's paintings of the 1870s, this one most completely abandons traditional methods of modelling, by gradations from dark to light tones, in favour of a composition based on clear colours, which model form and evoke space. The picture is dominated by the contrast between orange and blue, but the glowing bank of autumnal trees is built up from constantly varied warm hues; on the right, soft clear blues indicate the shadows in the trees, and the blues on the far buildings suggest recession into space.

The brushstrokes are varied, ranging from broad, firm strokes in the foreground reflections, which anchor the whole composition, to the dabs and hooks of colour in the shaded side of the tree on the right. Late in the execution of the picture Monet scraped away some of the paint in long, crisp strokes, probably with the handle of a brush; these are especially visible on the right tree, revealing the very light grey priming. Presumably they were the result of Monet's dissatisfaction with the density of the paint layers. JH

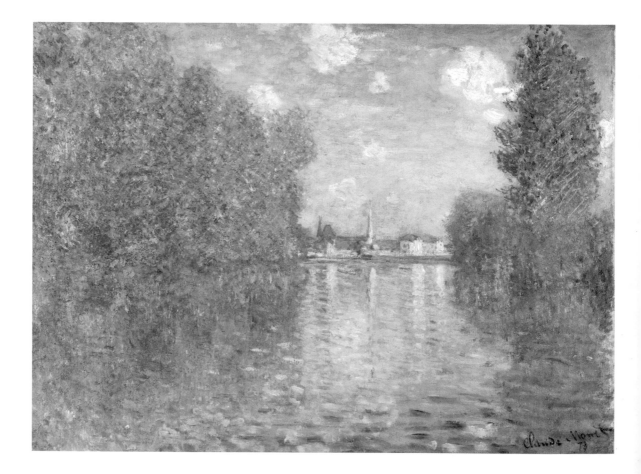

CLAUDE MONET (1840–1926)
Vase of Flowers, c.1881–82

Oil on canvas
100.4 x 81.8 cm
Samuel Courtauld Trust:
Courtauld Gift, 1932

Around 1880, for the only time in his career, Monet concentrated extensively on still lifes, alongside his painting of landscapes. In these years he was beginning to find a more regular market for his paintings, and he sold still lifes more readily than landscapes; when he found a regular market for his landscapes, he virtually gave up still-life painting. *Vase of Flowers*, a picture of a lavish display of wild mallow, belongs to the last group of still lifes that he undertook in this phase, a group of particularly large flower paintings, which, his letters show, caused him great trouble.

The final state of *Vase of Flowers* testifies to his difficulties. Although it is densely and elaborately worked, Monet did not complete it for sale at the time of its execution. It was one of many paintings from earlier years that he signed and sold in the last years of his life. In contrast to other paintings which he completed for sale in the 1880s (see pp 78–79), the forms of leaves and flowers in *Vase of Flowers* are less crisply handled, and treated in rapid dabs and dashes of colour that do not always define the forms clearly; the canvas does not succeed in finding a fully resolved pictorial form for this mass of blooms and greenery. Its vigorous, but slightly crude and even disorderly, touch is more akin to twentieth-century tastes than it would have been to those of the buyers of Monet's paintings in the 1880s. JH

CLAUDE MONET (1840–1926)
Antibes, 1888

Oil on canvas
65.5 x 92.4 cm
Samuel Courtauld Trust:
Courtauld Bequest, 1948

Monet worked at Antibes from February until May 1888; *Antibes* shows the view south-west from the Cap d'Antibes towards the Estérel Mountains.

At Antibes, Monet was faced with the problem of capturing the intensity of Mediterranean light and colour. He commented in a letter: 'What I bring back from here will be sweetness itself, white, pink and blue, all enveloped in this magical air.' Monet evoked the effect of this light by heightening his colours, and by co-ordinating the colour relationships throughout the picture. Here greens and blues are set against accents of pink, red and orange, with related colours recurring all over the canvas. By combining this weave of colours with emphatic complementary contrasts he suggested the effects of the southern sun.

Although it ostensibly conveys a transitory light effect, *Antibes* was extensively reworked. X-ray examination shows that the sea was originally executed more boldly and perhaps showed an effect of strong wind. During the execution of the picture, Monet also moved the position of the tree trunk to the left. These adjustments may have been made at Antibes, where he was plagued by changing weather conditions, but by this date he felt that the final touches on a picture needed to be added in the studio.

The composition of *Antibes*, with its silhouetted tree and open sides, reflects Monet's interest in Japanese prints, of which he was an avid collector; his knowledge of Japanese art helped him to find ways of formulating in pictorial terms the dramatic effects that he sought out on his travels during the 1880s. JH

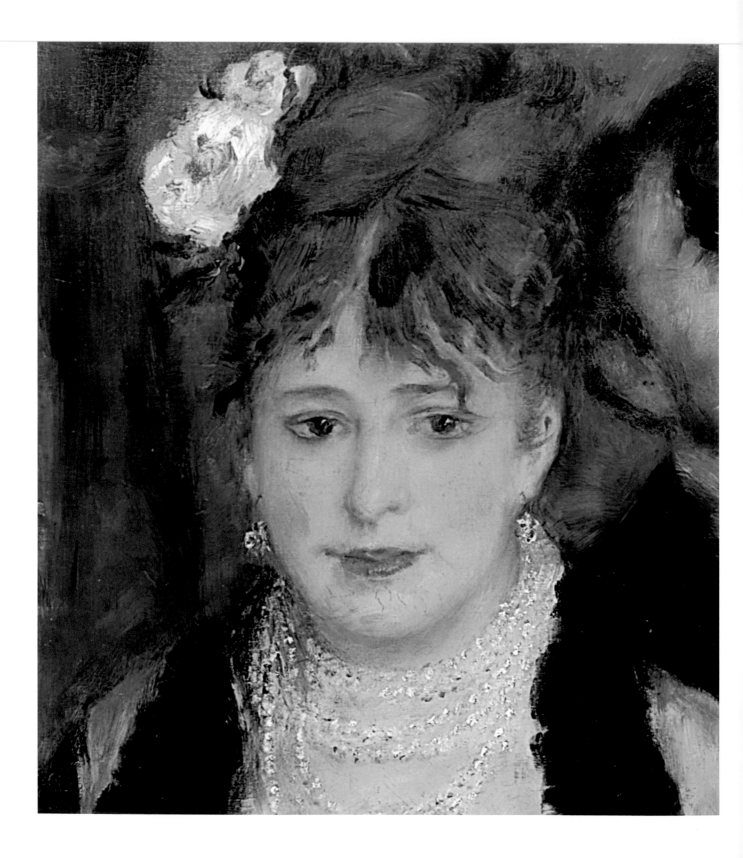

PIERRE-AUGUSTE RENOIR
(1841–1919)
La Loge, 1874

Oil on canvas
80 x 63.5 cm
Samuel Courtauld Trust:
Courtauld Bequest, 1948

Renoir's brother Edmond and a model from
Montmartre, Nini Lopez (known as 'fish-face'),
posed for this painting, which was one of Renoir's
prime exhibits at the first group exhibition of the
Impressionists in Paris in 1874. *La Loge* is very
different from Monet's *Impression, Sunrise*, the
rapid sketch whose title led to the naming of the
group, and far more elaborated than some of
Renoir's other exhibits at this show.

 Its technique is varied and fluent; forms are
delicately and softly brushed without crisp
contours, and the execution of the model's bodice
and the flowers is a particularly virtuoso display.
Her face is executed more minutely and more
fully modelled. The gown gives the composition a
strong black and white underpinning; black paint
is used here, though mixed with blue to suggest
the play of light and shade.

 The theatre box was a favoured subject
among painters of modern Parisian life during
the 1870s. Renoir contrasts the two figures, the
woman looking out with her opera glasses beside
her, as if to receive the gaze of other members of
the audience, while her male companion looks
upwards through his opera glasses, implicitly
towards another box, not at the stage. The viewer
is fully implicated in this play of gazes.

 Renoir left the social status of his model
ambiguous; one of the reviewers of the picture
described her as a typical *cocotte*, and humorously
used her as a warning to young girls not to be
waylaid by fashion and vanity, while another saw
her as 'a figure from the world of elegance'. JH

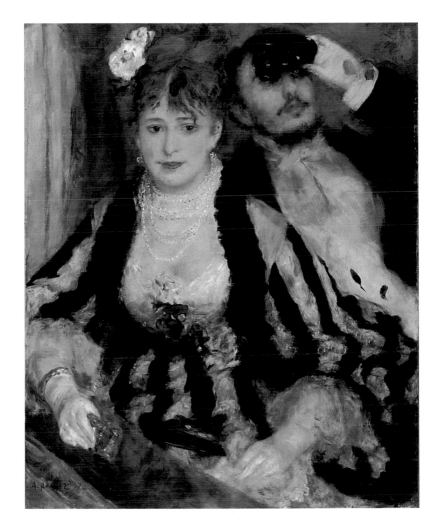

EDGAR DEGAS (1834–1917)
Two Dancers on the Stage, 1874

Oil on canvas
61.5 x 46 cm
Samuel Courtauld Trust:
Courtauld Gift, 1932

Two Dancers on the Stage relates to a group of compositions with many figures, depicting dancers rehearsing on a stage, but here Degas concentrates on the two figures, with stage-flats beyond them that seem to suggest foliage; we do not know whether we are watching a performance or a rehearsal from our viewpoint in a box virtually above the edge of the stage.

The figures are in standard ballet positions, and their gestures suggest some sort of interchange, but we are given little clue to the drama being enacted. It has recently been suggested that the painting represents the *Ballet des Roses*, which was included in performances of Mozart's *Don Giovanni* at the Paris Opéra from 1866. Our attempt to see this as a coherent, framed grouping is undermined by the appearance of the edge of a third dancer, her figure cut by the frame. There is also a paradoxical relationship between the elegance of the dancers' poses and their snub-nosed and slightly simian features. According to contemporary notions of physiognomy, in which Degas was much interested, features such as these were associated with a lower order of human development, and with the lower classes.

The ballet, with its precise movements, fascinated Degas, but he always presented it in ways that stressed its artificiality, by including extraneous elements: figures who do not watch the dancers, waiting dancers scratching themselves, or dancers who play no part in the main action, like the figure on the left here.

This canvas was exhibited by the Parisian dealer Durand-Ruel in his London gallery in November 1874, when it was bought by the pioneering Degas collector, Captain Henry Hill of Brighton. JH

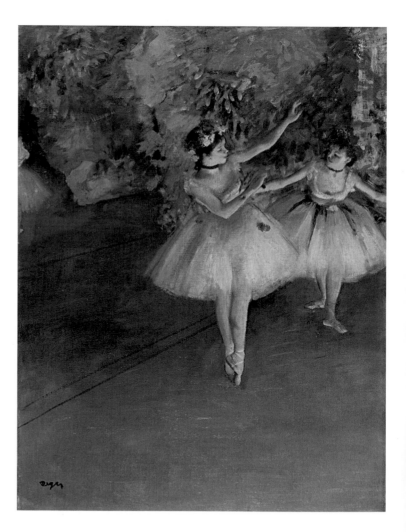

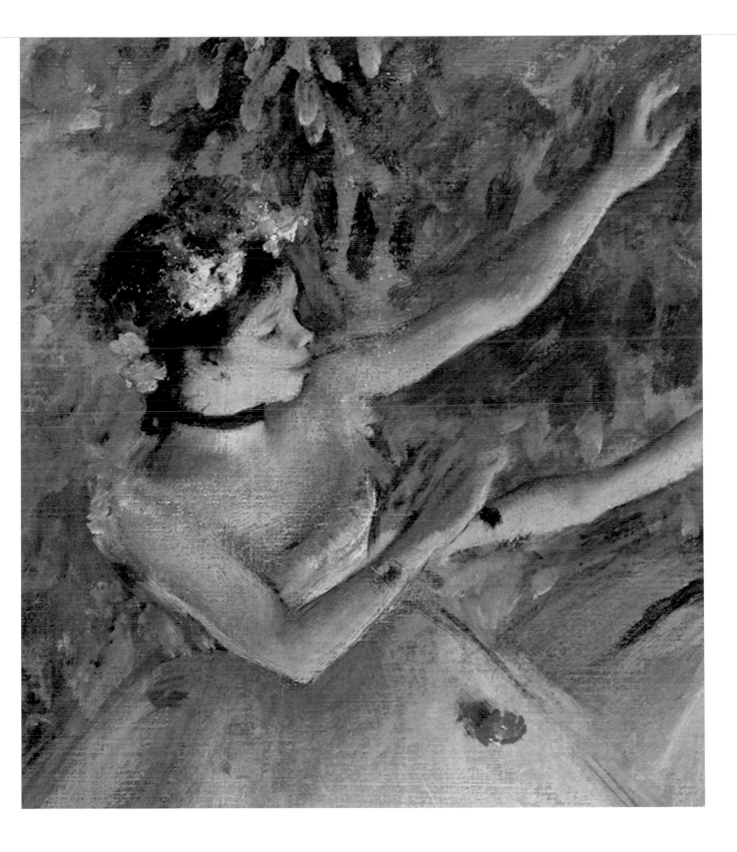

EDGAR DEGAS (1834–1917)
After the Bath, Woman Drying Herself,
*c.*1889–95

Pastel on tracing paper, laid down on cardboard
67.7 x 57.8 cm
Samuel Courtauld Trust:
Courtauld Gift, 1932

From the 1880s onwards, the subject of
women bathing or drying themselves became
one of Degas's central preoccupations. At
the eighth Impressionist group exhibition in
1886 he exhibited a set of pastels titled
Sequence of Nudes, of Women Bathing,
Washing, Drying, Wiping Themselves, Combing
their Hair or Having it Combed; this pastel
probably dates from a few years after this.
He told the poet George Moore that his aims
in his pictures of bathing women were to
show 'a human creature preoccupied with
herself – a cat who licks herself; hitherto, the
nude has always been represented in poses
which presupposes an audience, but these
women of mine are honest and simple folk,
unconcerned by any other interests than
those involved in their physical condition...
It is as if you looked through a key-hole.'

The pastel medium allowed Degas to
not only work more rapidly than with slow
drying oil paint, but also to explore diverse
colouristic effects, developing graphic
structures of variously formed strokes, marks
and lines integrated into a complex rhythm.
Using an innovative layering technique,
Degas fixed each layer of pastel before
covering it with the next, thus allowing
intense and controlled juxtapositions of
undisturbed colours, at once achieving
richness and lucidity. The working process,
starting with a vigorous linear charcoal
drawing, gradually enhanced with variously
applied colour, remains visible. JH & SB

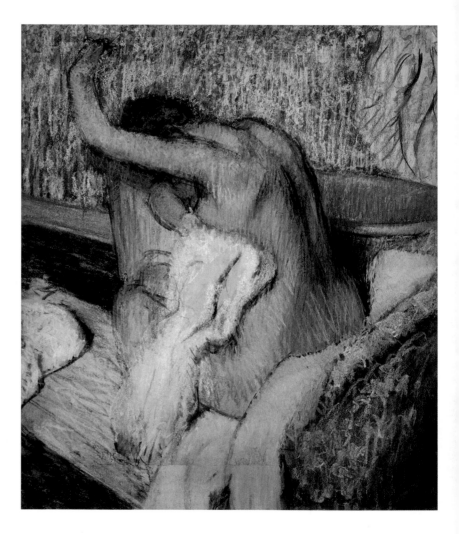

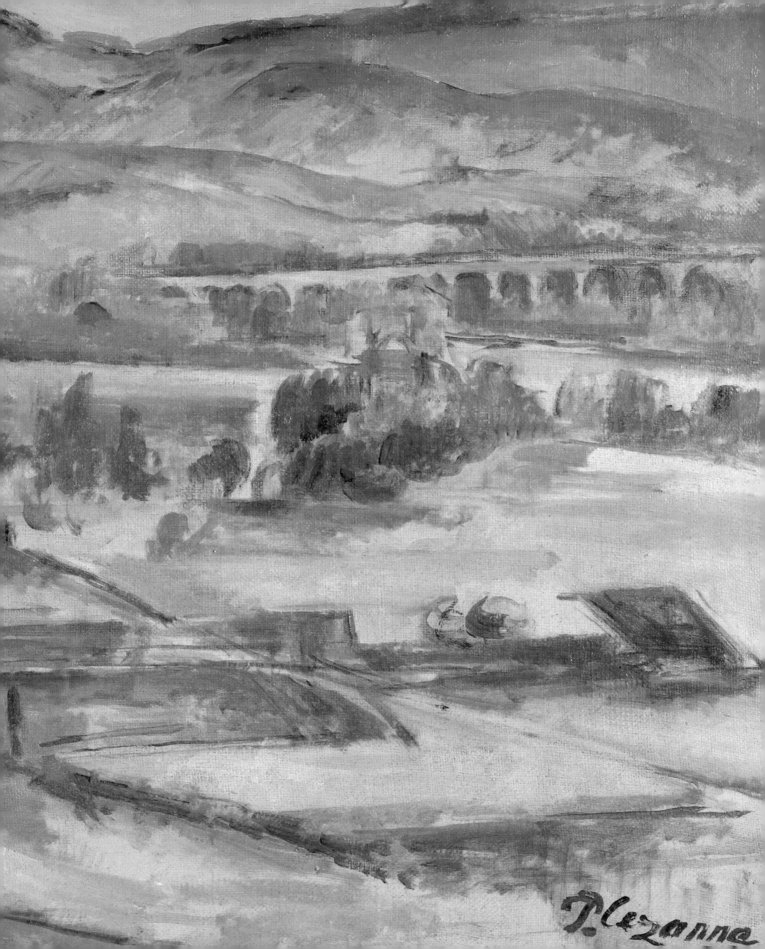

P. Cezanne

PAUL CÉZANNE
(1839–1906)
Montagne Sainte-Victoire, c.1887

Oil on canvas
66.8 x 92.3 cm
Samuel Courtauld Trust:
Courtauld Gift, 1934

The Montagne Sainte-Victoire lies to the east of Cézanne's birthplace, Aix-en-Provence; it was a subject to which he attributed great significance. Here it is seen from a point to the west of Aix; the mountain peak lies about eight miles away, but Cézanne, by focusing on a comparatively small part of the scene, gave it a dominant role in the composition. Although this view now appears unspoiled and even timeless, the presence of the railway viaduct at the far right would have been a contemporary reference for its original viewers.

In the early 1880s Cézanne had structured his canvases with extended sequences of parallel brushstrokes, but his technique is simpler here. Traces of the parallel brushstrokes remain in some of the foliage, but elsewhere the paint areas are less variegated; soft nuances of colour suggest surface textures and the play of light. The light cream priming, left bare at many points, contributes to the overall luminosity of the picture.

Recession is suggested by both colour and by line, with a gradual transition from the clearer greens and orange-yellows of the foreground to the softer atmospheric blues and pinks on the mountain; but even the foreground foliage is tinged with blues, and pinks and reds knit the foreground forms to the mountain. A network of more linear contours across the foreground also leads the eye into the distance.

When the painting was exhibited in Aix in 1895, it was received with incomprehension, but attracted the admiration of the young poet Joachim Gasquet; when Cézanne realised that Gasquet's praise was sincere, he signed the picture and presented it to him. JH

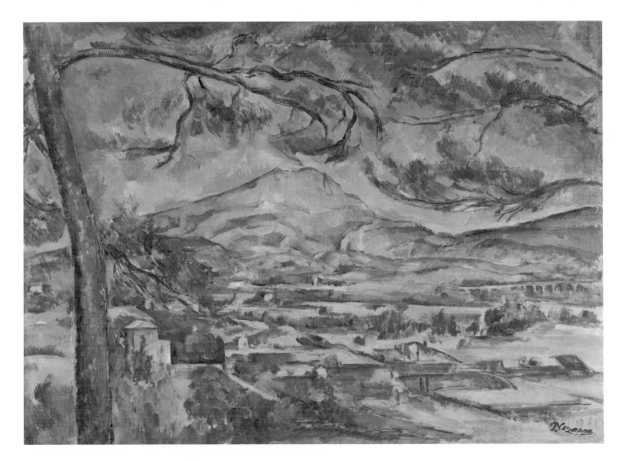

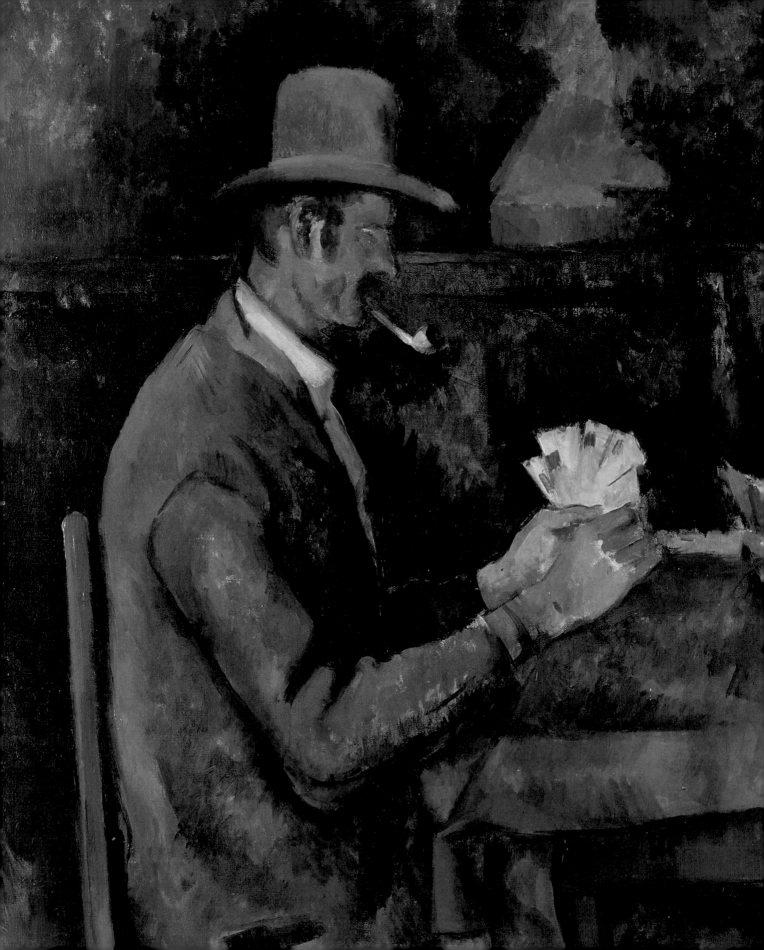

PAUL CÉZANNE
(1839–1906)
The Card Players,
*c.*1892–95

Oil on canvas
60 x 73 cm
Samuel Courtauld Trust:
Courtauld Gift, 1932

During the 1890s Cézanne painted many canvases of peasants from his home town of Aix-en-Provence. The most ambitious of these show men playing cards.

In this example the tonality is quite subdued, but subtle gradations of colour model the figures and their surroundings. A succession of warm accents revolve around the table-top, set against the soft blues, which suggest the atmosphere of the room; these cool hues are also varied, with a few sharper accents of clear green. The colour is simply and broadly applied for the most part, but crisper, delicate accents suggest the modelling of the men's faces.

The painting shows clear discrepancies with 'normal' natural vision: the verticals of the table lean to the left, and the knees of the left figure extend unduly far to the right. These distortions were not deliberate, but emerged during the execution of the painting, as Cézanne concentrated on relationships of colour and tone at the expense of the literal representation of the subject. When friends pointed out the oddities in his canvases, he used to laugh them off.

Cézanne's preoccupation with the organisation of his canvases does not mean that he was unconcerned about his subject matter. He felt that peasant life enshrined the basic values of his local region, which he saw as threatened by contemporary urban fashions. In this sense the image of peasants was a counterpart to his local landscapes, notably the Montagne Sainte-Victoire (see pp 86–87), which held such significance for him. JH

PAUL CÉZANNE (1839–1906)
*Still Life with Plaster Cupid, c.*1894

Oil on paper, laid on board
70.6 x 57.3 cm
Samuel Courtauld Trust:
Courtauld Bequest, 1948

Still life allowed Cézanne to choose and arrange the combinations of objects he depicted. *Still Life with Plaster Cupid* is one of the most complex of his still lifes. The plaster Cupid (formerly attributed to Pierre Puget) still remains in Cézanne's studio at Aix, as does the cast of a flayed man seen in the painting in the background. The Cupid cast is in reality 46 cm high, and it appears larger than life in the painting, as does the canvas, which is shown leaning against the wall on the left; the far apple, apparently placed on the distant floor, appears as large as the fruit on the table.

There are ambiguities, too, in the relationships between the objects. The drapery at the bottom left merges with the painted still life in the picture above it; the foliage of the onion fuses with the table leg in the same picture; and the back edge of the table-top virtually dissolves into the floor to the left of this onion.

The inconsistencies of the space are compounded by the paradoxes about the nature of the reality depicted, for example between 'real' and painted fruit and drapery. All of these devices stress the artificiality of the picture itself, and of the idea of still life, an assemblage of objects arranged in order to be painted. *Still Life with Plaster Cupid* was acquired by Samuel Courtauld in 1923 as the first of many works by Cézanne which would enter his private collection. JH

PAUL CÉZANNE
(1839–1906)
Lac d'Annecy, 1896

Oil on canvas
65 x 81 cm
Samuel Courtauld Trust:
Courtauld Gift, 1932

Lac d'Annecy was painted at Talloires in July 1896; in a letter Cézanne described the place as 'a bit of nature, but a little like we've been taught to see it in the albums of young lady travellers'. In this canvas, with its vibrant colour and monumental structure, he was clearly determined to transcend this commonplace picturesque.

The canvas is dominated by cool blues and greens, sometimes quite deep and sonorous in tone, but its principal focuses are the warm accents that run across it, where the morning sunshine strikes the objects in the scene. This contrast is brought into sharp focus on the left edge of the castle tower at the centre: the building is lifted forward from its surroundings both by the stroke of warm colouring and by this thread of light.

The picture is carefully structured, with the tree as a *repoussoir* on the left and its branches enclosing the top; the composition is anchored in the centre by the buildings and their reflections. A sequence of planes of colour links the nearby foliage to the far hillsides, but the cursive, graphic arcs that virtually detach themselves from the foliage accentuate the sense of rhythm and pattern across the canvas. By seeking to unify the whole surface Cézanne was not rejecting nature; rather, he said, he was seeking a 'harmony parallel to nature' that would transform his experiences of the visible world into a lasting, coherent form. JH

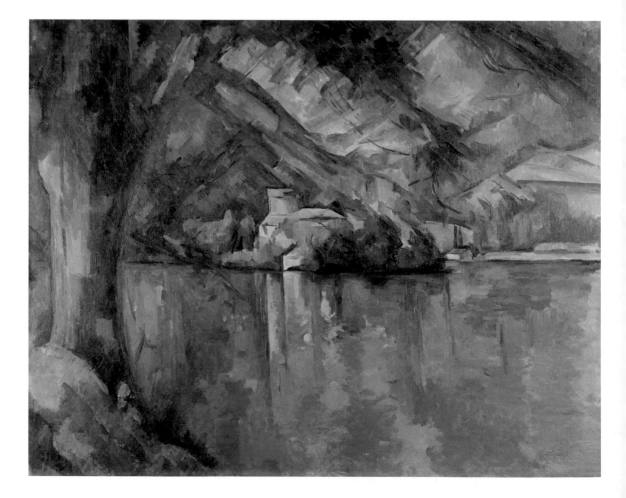

PAUL CÉZANNE
(1839–1906)
*Still Life with Apples,
Bottle and Chairback,
c.1904–06*

Watercolour and graphite
on wove paper
45.8 x 60.4 cm
Samuel Courtauld Trust:
Courtauld Bequest, 1948

A festive splendour of modulated colour, unrestrained lucidity of graphic structure and a subtle balance of relating forms characterise this still life as one of the most successful in Cézanne's *oeuvre*. As is typical of his late watercolours, the artist started with a loose pencil drawing of open arcs and free hatching, which do not outline the objects precisely but create a graphic map that organises the composition. Translucent watercolour was subsequently patiently layered on to the paper, creating a harmony of bright yellows and reds, complemented by blues that follow and accentuate the forms but which also float freely on the surface. The whiteness of the paper is integral to the work, indicating both the closest and the most distant points and unifying the composition.

Writing in 1905 to his friend the painter Emile Bernard, Cézanne declared that his 'only goal' was 'whatever our temperament or powers in the presence of nature, to re-create the image of what we see'. He understood this re-creation as a challenging, active process in which objects were not slavishly copied but their relationships – both in spatial and colouristic terms – explored and, finally, a harmonious composition developed. By depicting the objects in the present arrangement approximately in life-size, the comparison with nature receives the status of a proud rivalry while the classical hierarchy of genres, in which the still life occupies the lowest rank, is boldly challenged. SB

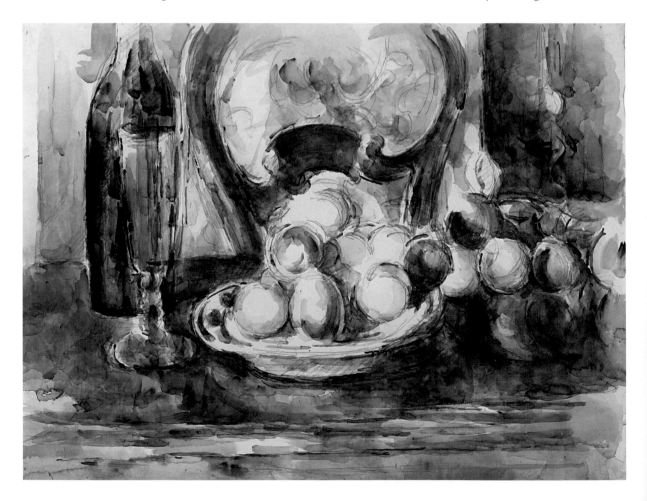

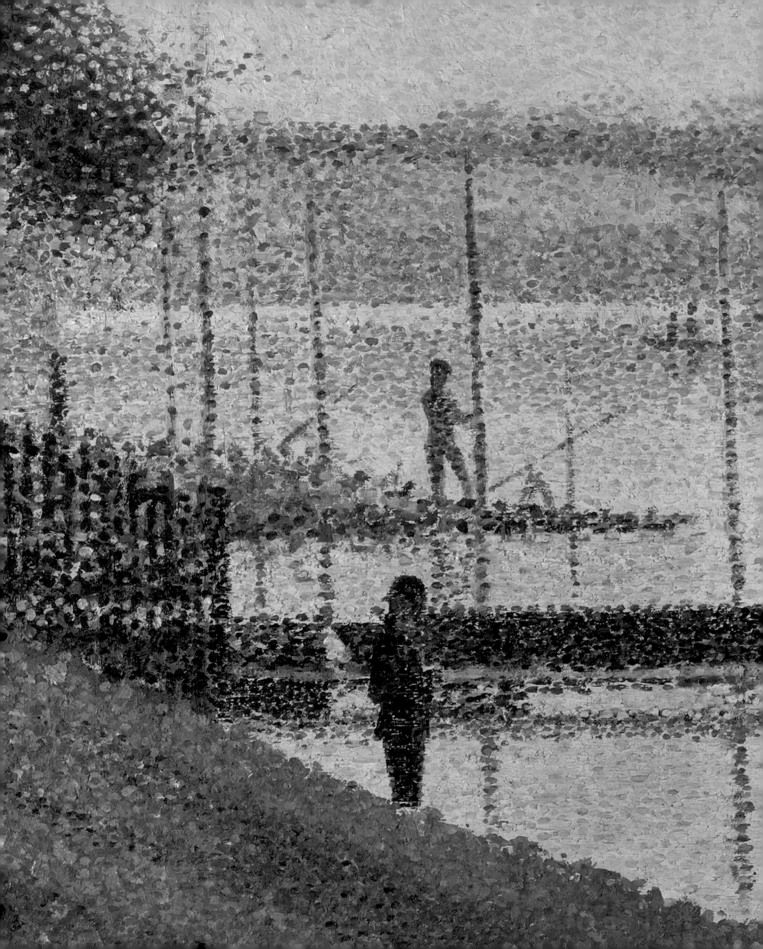

GEORGES SEURAT
(1859–91)
The Bridge at Courbevoie,
1886–87

Oil on canvas
46.4 x 55.3 cm
Samuel Courtauld Trust:
Courtauld Bequest, 1948

The Bridge at Courbevoie is a pictorial manifesto for the divisionist technique evolved by Seurat and his colleagues in 1885–86, as they sought to translate into paint the effects of natural light and colour, and to lend a scientific precision to the empirical solutions of the Impressionists. The individual 'point' of colour was the means that could best control the quantities of each colour used in any area of the picture. Although Seurat stated that the dots were intended to produce an 'optical mixture', this is not what takes place, for they are not small enough to fuse in the viewer's eye and produce a single resultant colour when viewed from a normal viewing distance. Rather, they shimmer and vibrate, suggesting the effects of outdoor sunlight, recreated through the complex artifice of painting technique.

Here the dominant colour on the grassy riverbank is green, lighter and yellower in the sunlight, duller and bluer in shadow; warm, pinker touches enliven the sunlit grass, and clear blues the shadowed areas. In addition there is a scatter of mauve touches across the shadowed grass, which reappear along the edge of the river. The overall effect evokes the play of sunlight through the interplay of warm and cool colours on the green riverbank.

The scene represents the Ile de la Grande Jatte, on the western outskirts of Paris, the scene of Seurat's *A Sunday Afternoon on the Ile de la Grande Jatte*, completed in the same year. In contrast to the elaborate parade of modern society in the Grande Jatte, the scene here is still and silent, with three small figures immobile by the river, set against the boats, bridge and factory chimney beyond. JH

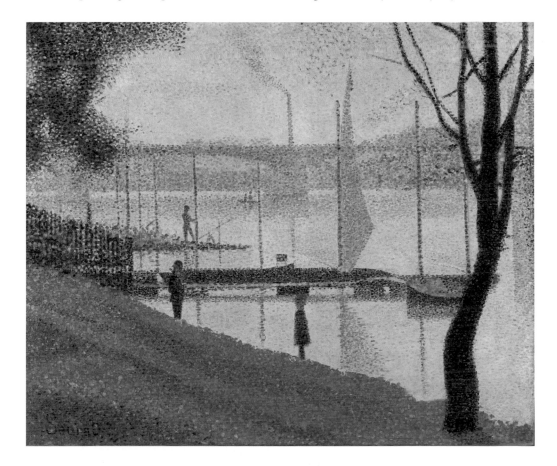

GEORGES SEURAT (1859–91)
Young Woman Powdering Herself,
*c.*1888–90

Oil on canvas
95.5 x 79.5 cm
Samuel Courtauld Trust:
Courtauld Gift, 1932

Young Woman Powdering Herself shows Seurat's
mistress, Madeleine Knobloch, at her toilette.
The painting is composed of a sequence of
contrasts between rounded and angular forms,
and presents a set of visual incongruities:
between the massive figure and her impracticably
small table, and between the curving lines of this
table and the frame above it.

Seurat never explained the picture's
meaning, but it includes his sign for happiness
and gaiety, the motif of lines rising from a point;
this decorates the wall and is echoed in many
ways in other parts of the picture. Seurat does not
seem to have been using these lines in a literal
way to uplift the viewer's spirits. They all belong
to the woman's personal décor, to her furniture
and cosmetics; her weighty presence and
impassive expression counteract them, and the
mood that emerges is ironic.

The picture plays on the contrast between
nature and artifice. It explores the art of
cosmetics, which, like the model's corsetry, forces
nature into the mould of style; we catch her in the
process making her natural self artificial. The
satire, though, is directed not against the model,
but against her trappings, a characteristic part of
modern urban life.

In contrast to *The Bridge at Courbevoie*
(pp 96–97), the brushwork and colours here do
not evoke the play of natural light; they create a
shimmering effect over the whole surface
without suggesting closely observed lighting.
The modelling of the figure is wilfully anti-
naturalistic; one cannot sense the form of the
model's hips and legs within the stylised curves
of her skirt. JH

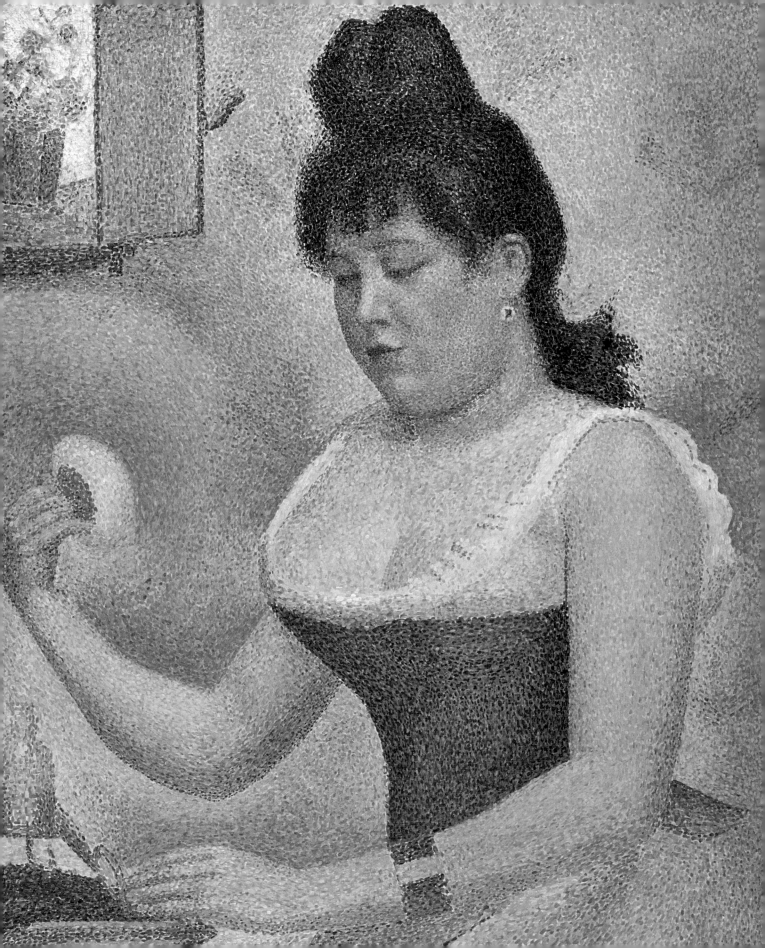

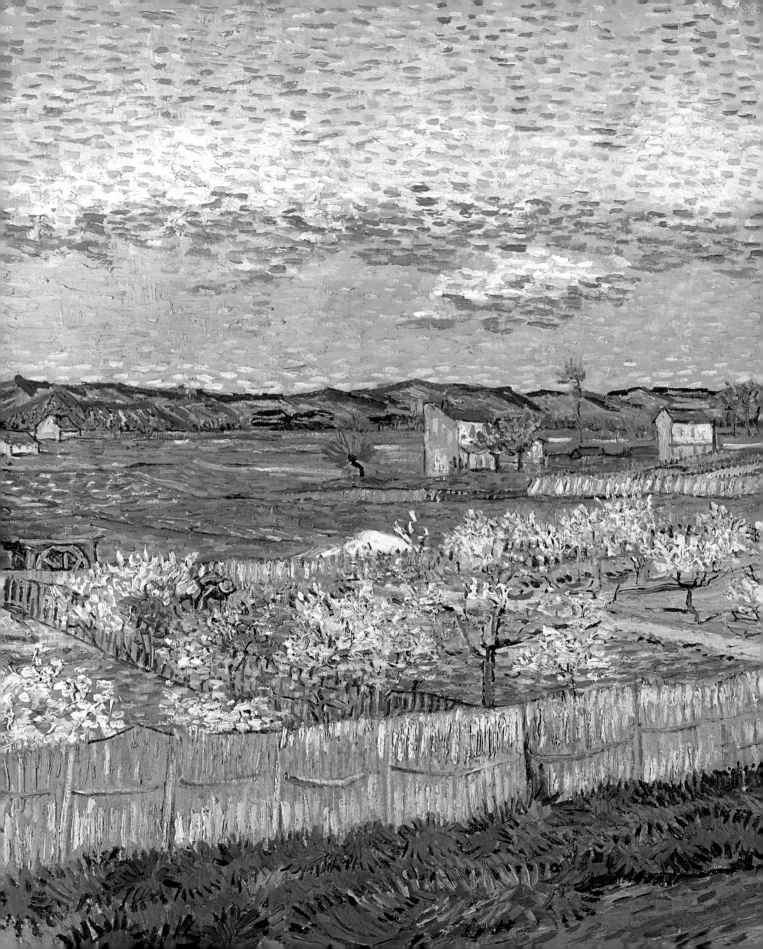

VINCENT VAN GOGH (1853–90)
The Crau at Arles: Peach Trees in Flower,
1889

Oil on canvas
65 x 81 cm
Samuel Courtauld Trust:
Courtauld Gift, 1932

Painted in Arles in spring 1889, this canvas shows a
view of the Crau, the wide plain to the north-east of
Arles. Van Gogh described the picture in a letter to
Paul Signac:

> a poor landscape with little cottages, blue skyline
> of the Alpille foothills, sky white and blue. The
> foreground, patches of land surrounded by cane
> hedges, where small peach trees are in bloom –
> everything is small there, the gardens, the fields,
> the orchards and the trees, even the mountains,
> as in certain Japanese landscapes, which is the
> reason why the subject attracted me.

The idea of the south of France as a western equivalent
of Japan had been one of van Gogh's reasons for
travelling to Arles the previous year. Van Gogh also
compared the wide spaces of the Crau to the
panoramas of Dutch seventeenth-century landscape
painting. The working figure on the left of the picture
and the prominent small houses emphasise that this
was a social, agricultural landscape, its forms the
result of man's intervention.

This canvas was painted after Gauguin's visit
to Arles, during which he had advised van Gogh to
work from his imagination (see pp 102–03). It marks
van Gogh's renewed commitment to painting from
nature. He conveys the textures of the scene with a
great variety of brush marks, some broad and incisive,
others of extreme finesse. The dabs of paint in the
blossom reflect his study of Impressionist painting
in Paris, but elsewhere the handling is more precise,
particularly the web of fine, dark red strokes added in
many parts of the picture late in its execution to
emphasise the forms of the elements shown. JH

VINCENT VAN GOGH (1853–90)
Self-Portrait with Bandaged Ear, 1889

Oil on canvas
60 x 49 cm
Samuel Courtauld Trust:
Courtauld Bequest, 1948

SATO TORAKIYO (publisher)
Japanese, 19th century
*Geishas in a Landscape, c.*1870–80

Coloured woodblock print
60 x 43 cm
Samuel Courtauld Trust:
Gift of Professor Shigeru Oikawa, 2005

In December 1888, van Gogh mutilated his ear after a quarrel with Paul Gauguin, who was staying with him in Arles in southern France. This event and Gauguin's departure marked the end of van Gogh's dreams of setting up a 'studio of the South', where like-minded artists could share ideas and resources. This was one of the first pictures that van Gogh painted after his release from hospital in January 1889.

Van Gogh's disagreements with Gauguin were grounded on a fundamental aesthetic issue: whether the painter should work from nature or imagination. For Gauguin subservience to external appearances marked a lack of creativity, while van Gogh found rich meanings in the observation of the natural world. During Gauguin's stay he painted a few canvases from the imagination, but *Self-Portrait with Bandaged Ear* marks his reversion to an aesthetic grounded in nature. The painter is standing in clear daylight and translates his own appearance into highly varied and improvisatory rhythms of touch and colour, in marked contrast to the simplified, schematic surfaces that Gauguin advocated.

The imagery of the portrait evidently relates to the recent disruption of his life. The bandaged ear is given great prominence, and on each side of the painter's head we see a highly loaded image: to the left, an easel with a scarcely worked canvas on it; and to the right, a Japanese colour print (of which the Gallery has an impression) that shows an idyllic view of Japan as a land of beautiful women and landscape. Together they seem to evoke the contrast between his past dreams of artistic renewal in the south of France and his present sad circumstances. JH

PAUL GAUGUIN (1848–1903)
Mette Gauguin, 1879

Marble
Height 34.5 cm
Samuel Courtauld Trust:
Courtauld Gift, 1932

This portrait bust of Paul Gauguin's Danish wife, Mette (born Mette Sophie Gad), dates from the early years of the artist's career. The broad forehead, sunken eyes, long nose and wide jaw form a faithful portrait of the 29-year-old Mette, already a mother of two and expecting her third child. Something of Mette's strength of character also comes through in her determined expression and steady forward gaze. The use of a drill for the eyes and lace collar gives tone and texture to the otherwise smooth volume of the face.

Gauguin's two sculpted portraits of family members (the other is of his son Emil) are important as the artist's only known works in marble. They show a level of technical skill and sophistication in the handling of the material that is surprising in someone who never received any formal training as a sculptor. The full extent of Gauguin's involvement in carving this work is not known, and it is assumed he received assistance from an academically trained sculptor and stone carver, Jules-Ernest Bouillot, who was the Gauguins' landlord at the time. Gauguin may have merely provided Bouillot with a clay model for translation into marble, but it is plausible that he carved much of the work himself, with Bouillot offering help when necessary. Gauguin was proud of his portrait of Mette, which he signed and exhibited at the fifth Impressionist exhibition of 1880 and the Paris Salon. The portrait remained with Mette and her family until the mid-1920s, when it was acquired by Samuel Courtauld. AG

PAUL GAUGUIN (1848–1903)
The Haystacks, 1889

Oil on canvas
92 x 73.3 cm
Samuel Courtauld Trust:
Courtauld Gift, 1932

Gauguin had first visited Pont-Aven in 1886, partly to get away from Paris, and partly to find a cheaper place to live. Brittany was by then becoming an attractive tourist centre, and paintings that featured picturesque Breton costumes and customs were commonly shown at the annual Salon exhibitions in Paris. At Pont-Aven, one of the main artists' colonies in Brittany, a group of younger painters formed around Gauguin. They shared his commitment to rejecting naturalistic depiction in favour of an art that expressed the primitive essence of Breton life.

Gauguin had worked with Pissarro in the late 1870s and early 1880s, and sometimes painted in a very similar style. In the mid-1880s he began to simplify his forms, replacing the rich textural surface effects associated with Impressionism with clearer, more stylised surface patterns. In *The Haystacks* the brushwork is quite tight and crisp, lacking the density and flexibility of Pissarro's. Gauguin had painted with Cézanne in 1881 and owned a collection of his work; the sequences of parallel strokes here somewhat reflect Cézanne's example. However, Gauguin's brushwork is thinner and streakier, his drawing far more schematic, and there is little hint of the nuances of atmospheric colour so prominent in Cézanne and Pissarro's work. Moreover, Gauguin presented the space in his picture in a way that cannot readily be understood. The forms seem stacked one on top of the other; the fine diagonal strokes above the necks of the oxen ignore the spatial recession that is suggested below and to the right of the bush. JH

PAUL GAUGUIN (1848–1903)
Nevermore, 1897

Oil on canvas
60.5 x 116 cm
Samuel Courtauld Trust:
Courtauld Gift, 1932

Gauguin painted *Nevermore* in February 1897, during his second visit to Tahiti. He described it in a letter to Daniel de Monfreid:

> I wished to suggest by means of a simple nude a certain long-lost barbarian luxury. The whole is drowned in colours which are deliberately sombre and sad; it is neither silk, nor velvet, nor batiste, nor gold that creates luxury here but simply matter that has been enriched by the hand of the artist... As a title, *Nevermore*; not the raven of Edgar Poe, but the bird of the devil that is keeping watch.

Nevermore belongs to a tradition of reclining female nudes, but Gauguin introduced a new dimension of private experience to the theme. There is a relationship between the nude figure with her turned eyes, the bird, seemingly watching, and the clothed figures in the background. The turn of the nude's eyes suggests that she is aware of the bird or the other figures, but beyond this nothing is clear.

Gauguin's reference to 'a certain long-lost barbarian luxury' suggests that the image should be understood not just as the awakening of a particular woman but rather in relation to the corruption of 'primitive' cultures by the influx of western values. The bird's role, too, is ambiguous. Although in his letter Gauguin played down its relationship to Edgar Allan Poe's 'The Raven', the painting's original viewers would have associated the bird, and the picture's title, with Poe's poem, in which the bird stands ominously above the poet's door, croaking 'Nevermore'. In the picture, it contributes, with the conversing figures, to the sense of threat that invades the luxury of the nude's surroundings. JH

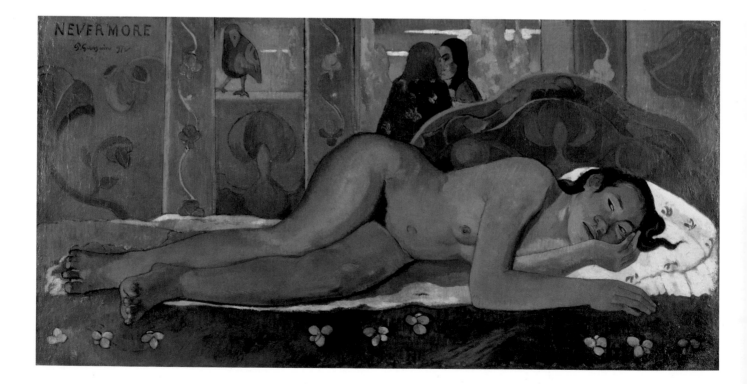

PAUL GAUGUIN (1848–1903)
Te Rerioa (The Dream), 1897

Oil on canvas
95.1 x 130.2 cm
Samuel Courtauld Trust:
Courtauld Gift, 1932

Te Rerioa was painted in Tahiti in March 1897,
shortly after *Nevermore*. The decorations on the walls
were probably imaginary, invented as appropriate
décor for the picture; the carvings on the cradle-head
derive from a carving that Gauguin saw in the
Auckland Museum on his way to Tahiti in 1895.

Gauguin described the painting in a letter to
Daniel de Monfreid:

> *Te Rereioa* (The Dream), that is the title.
> everything is dream in this canvas; is it the
> child? is it the mother? is it the horseman
> on the path? or even is it the dream of the
> painter!!! All that is incidental to painting,
> some will say. Who knows. Maybe it isn't.

The uncertainties that Gauguin playfully spelt out
are integral to the painting; no figures communicate
with each other, and none has a legible expression.
The image is made up from a set of contrasts,
between sleeping and waking, activity and passivity,
female and male, indoors and outdoors. Gauguin's
letter emphasises that none of the elements in the
picture are 'real'; all are the creation – the dream –
of the painter. This attitude to meaning was closely
in line with the aesthetic of the Symbolist poet
Stéphane Mallarmé.

Te Rerioa was intended for a European audience,
presenting an image of 'primitive' reverie and a
fusion of eroticism and innocence. This bore no
relation to the state of society in Tahiti in the 1890s,
but the picture contributed to a long European
tradition of images of the 'noble savage'; these idyllic
visions of the 'otherness' of non-western cultures
were expressions of dissatisfaction with the values
of western society. JH

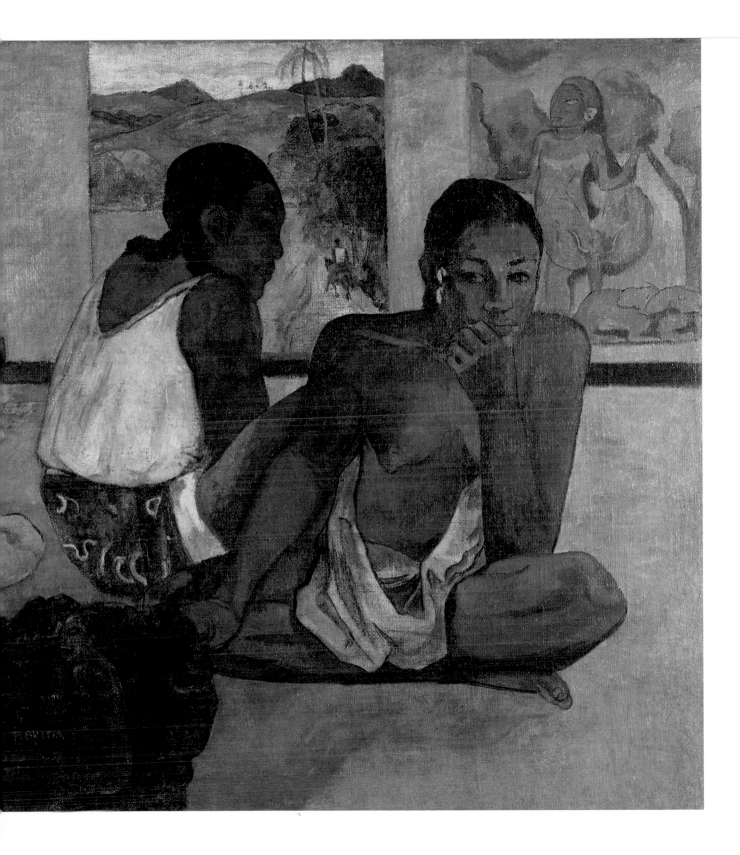

HENRI ROUSSEAU ('LE DOUANIER')
(1844–1910)
*The Toll-Gate, c.*1890

Oil on canvas
40.6 x 32.75 cm
Samuel Courtauld Trust:
Courtauld Bequest, 1948

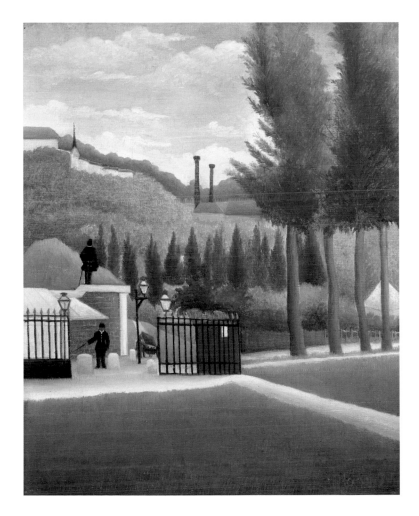

Rousseau worked as a customs official from 1871
to 1893, manning toll-gates on the outskirts of
Paris. He began exhibiting with the jury-free
Société des Artistes Indépendants in 1886. Only
after the institution of a jury-less exhibition such
as the Indépendants could an artist like Rousseau,
wholly outside the institutional frameworks of the
art world, find an outlet for his work.

Despite his complete lack of formal training,
Rousseau's initial models as a painter were the
academic neo-classicists Jean-Léon Gérôme and
Charles Clément. The subjects of his large
pictures – exotic jungles (which he never visited
in reality) and large-scale allegories – are also
comparable to favoured themes in academic art.
But Rousseau also painted many smaller
landscapes, like *The Toll-Gate*, which show the
everyday surroundings of the Parisian suburbs.
These often focus on the intrusion of distinctively
modern elements into the scene, like the
chimneys here, and mainly depict the regions
where he worked, near the toll-gates that
ringed the city; it is one of these gates that is
shown here.

Rousseau knew little about linear or
atmospheric perspective, but laid the elements in
his scenes across the picture surface, suggesting
space by successions of planes stacked one above
the other so that objects on the horizon are as
crisply defined as those nearby. Forms are treated
as silhouettes, like the figures here, or, like the
tree trunks, as simple cylindrical tubes. Out of
these subjects, though, he created paintings tautly
organised in two-dimensional terms: verticals and
horizontals, from clouds to footpaths, mesh into
patterns of great coherence. JH

HENRI DE TOULOUSE-LAUTREC
(1864–1901)
Jane Avril in the Entrance of the Moulin
Rouge, c.1892

Pastel and oil on millboard,
laid on panel
102 x 55.1 cm
Samuel Courtauld Trust:
Courtauld Gift, 1932

Jane Avril was one of the star performers of
Paris's famous Moulin Rouge, where she
made her début as a dancer in 1889. Her
highly charged stage routines earned her the
nickname 'Mélinite' (a recently invented form
of explosive). She became one of Lautrec's
favourite models and a close personal friend.
The artist produced numerous depictions
of her, including advertising posters for
her shows in which she is immediately
identifiable, sensuously dancing a version
of the cancan in her trademark bonnet and
lavish underskirts. As well as helping to
create her public persona as a packaged
celebrity, in this work Lautrec captured a
moment from her private life. Dressed in
street clothes, perhaps arriving before a
performance, she appears gaunt and
consumed by her own thoughts. The hat
and coat hanging on the wall intrude on
this private quality as reminders of her
many male admirers.

Lautrec deployed an experimental
combination of techniques here, laying
in broad areas of oil paint, which he then
worked over with pastel. This allowed him
to combine colour and drawing in order
to define the forms more sharply while
enriching the play of colours. It is used to
great effect in the area of Jane Avril's face
and bonnet, where fine strokes of reds,
yellows and greens are set off against the bold
application of blue paint in the background.
This focuses our attention on the delicacy and
fragility of her expression, offering a hint of
the person behind the celebrity. BW

HENRI DE TOULOUSE-LAUTREC
(1864–1901)
The Jockey, 1899

Lithograph, first state, printed in black ink
51.6 x 36.3 cm
Samuel Courtauld Trust:
Courtauld Gift, 1935

For Toulouse-Lautrec, one of the greatest masters of the technique, lithography assumed an importance in his *oeuvre* equal to that of painting. He relished its spontaneity, as is evident from the lively and inventive way he portrays these racehorses running flat out at Longchamp (the course is identified by the windmill at the right) As if in an action photograph, the rear-view image of the thoroughbreds gives an instant impression of power and speed. Such lifelike interpretations as these were aided by the discoveries on animal locomotion made by the photographer Eadweard Muybridge in the 1870s. The strong diagonal thrust and boldly silhouetted shapes, dominated by the foreground horse's muscular hindquarters and the outline of the jockeys rising in the mount, reveal the influence of Japanese prints on the artist's work.

Toulouse-Lautrec first trained informally in Paris with a sports artist, René Princeteau, who taught him to draw horses – a subject for which he had a particular fascination. Around 1898, guided by Tristan Bernard, a seasoned race-going friend, his interest in horseracing was revived. *The Jockey* is the first plate in a series of colour lithographs of equestrian subjects entitled *Les courses,* commissioned by the Parisian publisher Pierrefort. Only four in the series were completed before Toulouse-Lautrec fell ill and died. *The Jockey*, one of his most magnificent lithographs, was printed in two states in the studio of Henri Stern. This print is one of only ten black-and-white impressions in the first state; 112 impressions were printed in colour in the second state. JS

AMEDEO MODIGLIANI
(1884–1920)
Female Nude, c.1916

Oil on canvas
92.4 x 59.8 cm
Samuel Courtauld Trust:
Courtauld Gift, 1932

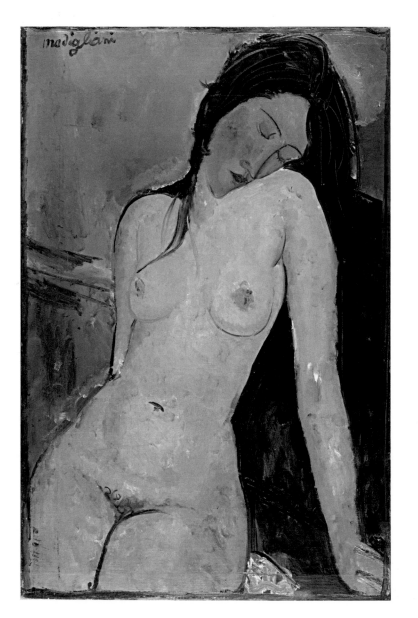

Modigliani's *Female Nude* is a radical reworking of
the conventions of figurative painting and sculpture
in western art. The sensuous pose of the sleeping
model, her head tilted to one side, is typical of the
vast number of classicising nudes that were shown
annually at the Salon in Paris. However, the
woman's elongated face and boldly simplified
features derive in generalised terms from the
traditions of non-western art and testify to
Modigliani's knowledge of Egyptian, African and
Oceanic sculpture. Moreover, his rough handling of
paint ran counter to the highly finished, smoothed
surfaces found in most Salon nudes at this time.
Here he applies the paint with a short stabbing
action, manipulating it whilst still wet so that the
marks of his stiff brush are clearly visible, as are the
deeply scratched lines made with the end of his
brush to accentuate the model's hair.

Modigliani's combination of conventional and
avant-garde elements effectively fused the classical
aesthetics of western art with that of other cultures:
a conjunction that contemporaries considered an
affront to the grand tradition of European painting.
However, it was Modigliani's explicit depiction of
pubic hair in his nudes – a taboo in Salon paintings
– that proved most controversial and led to the
police closing his exhibition at Berthe Weill's gallery
in 1917 on the grounds of indecency. BW

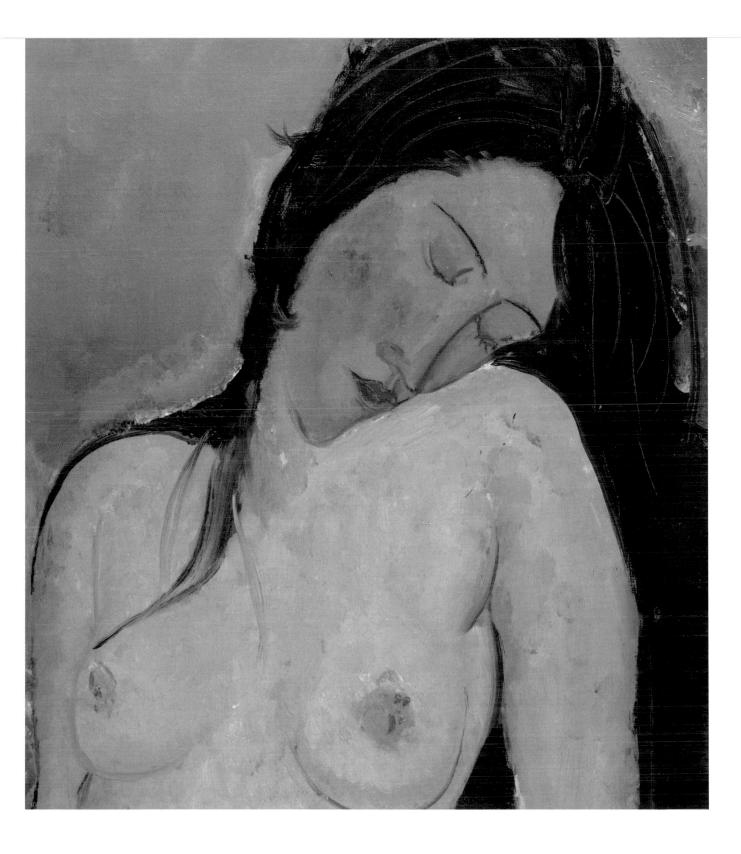

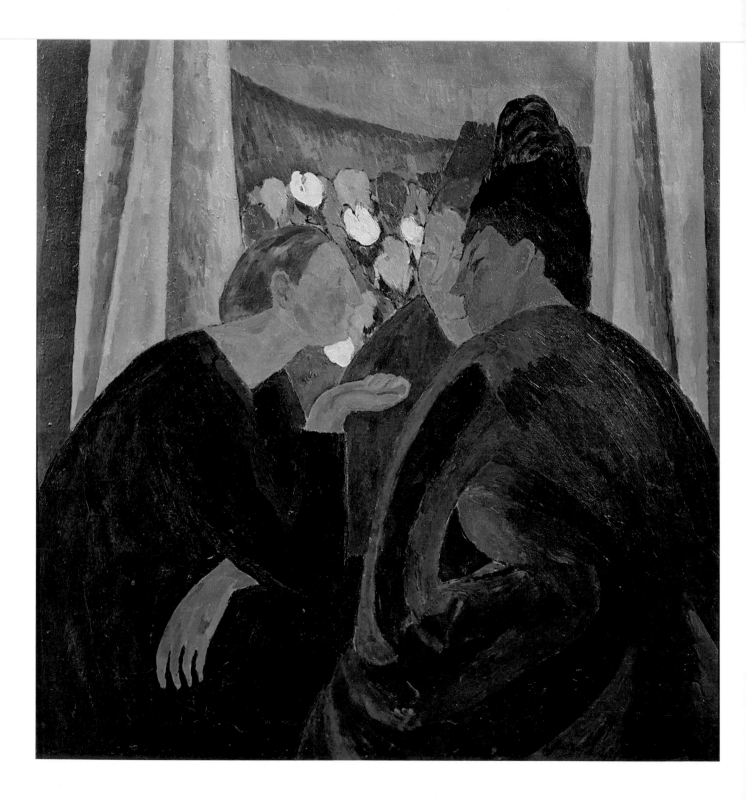

VANESSA BELL (1879–1961)
A Conversation, 1913–16

Oil on canvas
86.6 x 81 cm
Samuel Courtauld Trust:
Fry Bequest, 1935

Vanessa Bell was one of the leading figures of a loose assimilation of like-minded artists, writers and intellectuals known as the Bloomsbury Group, who came to prominence in the first half of the twentieth century. This painting's depiction of an intimate conversation between three women reflects the group's belief in the importance of close friendships and shared discussions to generate new ideas that challenged the entrenched moral, cultural and sexual attitudes of the previous generation.

This painting belonged to Bell's close friend the artist and critic Roger Fry, who had introduced the work of the French Post-Impressionists to Britain in an exhibition held at the Grafton Galleries, London, in 1910. In its simplifications of form and colour, *A Conversation* has affinities with the work of Gauguin and also with the art of the so-called 'Italian Primitives' of the fourteenth century, whom Fry encouraged Bell to study. It seems that Bell began the canvas in 1913 and revisited it in 1916, making a number of important changes. Technical examination suggests that the figure on the right was initially a man holding a cane, and other alterations are still visible beneath the paint surface. For example, the stripes of a once patterned blouse can be seen on the left-hand figure, as can swirling brushstrokes on the curtains, suggesting that they were originally decorated more elaborately. It would seem that in making these changes during the years of the First World War, Bell imbued the painting with a greater sense of solemnity. BW

ROGER FRY (1866–1934) and
ARNOLD DOLMETSCH (1858–1940)
Spinet, 1917–18

Painted wood
82.1 x 101.8 x 104.5 cm
Inscribed: *ARNOLD DOLMETSCH*
FECIT ANNO MCMXVII ROGER FRY
ORN. ANNO MCMXVIII
On loan from a private collection

This spinet was designed by the leading early instrument maker Arnold Dolmetsch for the Bloomsbury painter and art critic Roger Fry. Fry's brightly painted decorative scheme involves a striking combination of two different visual languages. The exterior decoration is entirely abstract. It is made up of a patchwork of simple geometric forms and patterns suggesting plants or musical instruments. The overall effect was inspired by the great Cubist collages of Picasso and Braque, whom Fry both knew and admired. When opened, the instrument reveals its main decorative

feature: a monumental female nude semi-reclining in an ideal landscape. The figure's pose and body are stretched out to fit the shape of the object. A band of stylised cyclamen motifs decorates the sounding board, providing a solid visual base for the figure and serving also to link the various parts of the instrument together. Both the nude and the flowers are consciously indebted to the decorative traditions of Renaissance Italy. The inscription, recording the work of both Fry and Dolmetsch on this piece, is also a homage to Renaissance ideals of artistic collaboration. AG

BEN NICHOLSON
(1894–1982)
Painting 1937, 1937

Oil on canvas
79.5 x 91.5 cm
Hunter Bequest, 1984

Ben Nicholson first produced abstract work in 1924, but during the 1930s he pursued the creative possibilities of geometric abstraction with a new sense of purpose. During this period he became part of a community of avant-garde artists and critics in Paris and was invited to join the Abstraction-Création group in 1933, when he first met Piet Mondrian. The following year he began a series of painted white reliefs, now considered to be his first major contribution to international modernism. He also started to apply his uncompromisingly non-representational aesthetic to coloured paintings such as *Painting 1937*. This work marks an important year for Nicholson, when London briefly became the centre for the Constructivist art that he championed. He helped organise an important exhibition, *Constructive Art*, at the London Gallery and oversaw the publication of

Circle: International Survey of Constructive Art, which he co-edited with Naum Gabo and the architect Leslie Martin (the first owner of this painting).

Painting 1937 demonstrates the assured sophistication of Nicholson's approach to abstraction, which departs from Mondrian's use of grids to organise its geometric composition. Here the coloured forms can be read as both interlocking shapes and as layered squares and rectangles. The eye is immediately drawn to the central red square, around which different relationships of form and colour are arranged, the strongest contrasts being with the areas of black and the now faded yellow. The visual weight of the coloured planes gives an illusion of depth recalling the construction of the three-dimensional reliefs and sculptures that Nicholson was also producing at this time. BW

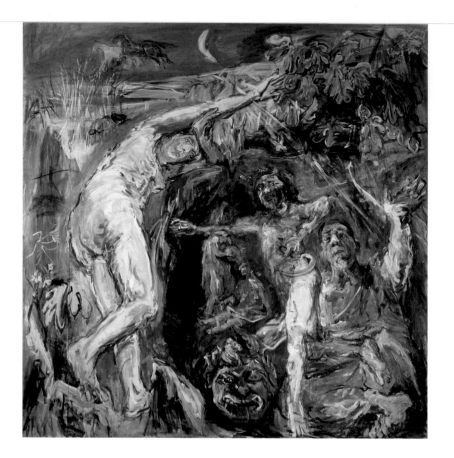

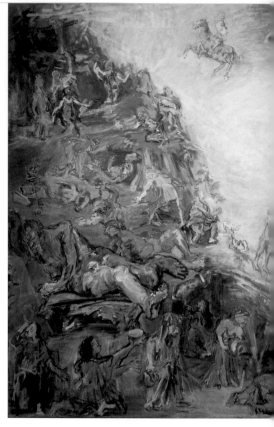

OSKAR KOKOSCHKA (1886–1980)
*The Myth of Prometheus
Triptych*, 1950
Hades and Persephone (left);
The Apocalypse (centre);
Prometheus (right)

Oil and tempera on canvas
239 x 234 cm (left wing),
239 x 349 cm (centre),
239 x 234 cm (right wing)
Samuel Courtauld Trust:
Princes Gate Bequest, 1978

Oskar Kokoschka was commissioned to produce this large triptych in 1950 by Count Antoine Seilern for the entrance-hall ceiling of his London house, 56 Princes Gate. Kokoschka spent over six months working on the three canvases on easels *in situ*. On 15 July he wrote: 'I put the last brush-stroke (I feel like saying axe-stroke) to my ceiling painting yesterday...'. The commission afforded Kokoschka the opportunity to produce a monumental work following the tradition of Baroque masters such as Rubens and Tiepolo, whom he greatly admired and whose work formed a central part of Seilern's collection.

The biblical and mythological subject matter expresses Kokoschka's fears for the fate of mankind at the beginning of the Cold War period. The central canvas shows the

Four Horsemen of the Apocalypse charging towards the unsuspecting figures on the hillside opposite. This apocalyptic vision is flanked in the right-hand canvas by an image of Prometheus punished by Zeus for stealing the fire of divine wisdom. For Kokoschka Prometheus symbolised 'Man's intellectual arrogance' and his desire for power beyond his control. In the left-hand canvas are the earth goddess Demeter and her daughter Persephone, freed from the clutches of Hades, god of the underworld (represented as a self-portrait of the artist). This scene offers the hope of freedom and regeneration, which Kokoschka maintained was only possible by returning to compassionate maternal values, depicted here as the joyful reunion of mother and daughter. BW

JOHN HOYLAND (born 1934)
Verge 12.10.76, 1976

Oil on canvas
190 x 129.8 cm
Hunter Bequest, 1984

During several visits to New York in the 1960s John Hoyland became immersed in the art of the Abstract Expressionists and the formalist theories of the influential critic Clement Greenberg, whom he met in 1964. Hoyland shared their commitment to pure abstraction and the material qualities of paint, and his work from this period explores the creative possibilities of large planes of colour, often thinly applied. During the 1970s he moved beyond the boundaries of form and colour to express a delight in the physicality and texture of paint itself. In *Verge*, Hoyland applies the paint in successive layers using a variety of tools, including a brush, palette knife and large scraper. The central irregularly shaped slab covers much of the painting activity beneath and appears dominant and monumental in its form.

However, Hoyland is sensitive to the ways in which this monolithic shape interacts with the other areas of the canvas; its sharply delineated edges contrast with the less defined range of textures and marks on which it rests. Its two tones of muted green and yellow, scraped through one another, accentuate the vibrancy and energy of the surrounding colours, further emphasising the boundaries of its form. The result is a rich and complex image that expresses the gradual process of its making through a palimpsest of different paint layers that have both visual and temporal depth.

Verge was bequeathed to the Courtauld Institute of Art by Dr Alastair Hunter in 1984 as part of a collection of works by British artists, predominantly of the 1960s and 1970s. The collection, which includes paintings by Ivon Hitchens, Patrick Heron and Prunella Clough, extends the chronological range of the Courtauld's holdings into the later twentieth century. BW

INDEX